DAVID BUSCH'S CLOSE-UP AND MACRO PHOTOGRAPHY

COMPACT FIELD GUIDE

David D. Busch | Rob Sheppard

Course Technology PTR

A part of Cengage Learning

COURSE TECHNOLOGY
CENGAGE Learning·

Australia, Brazil, Japan, Korea, Mexico, Singapore, Spain, United Kingdom, United States

COURSE TECHNOLOGY
CENGAGE Learning·

David Busch's Close-Up and Macro Photography Compact Field Guide
David D. Busch, Rob Sheppard

Publisher and General Manager, Course Technology PTR:
Stacy L. Hiquet

Associate Director of Marketing:
Sarah Panella

Manager of Editorial Services:
Heather Talbot

Senior Marketing Manager:
Mark Hughes

Executive Editor:
Kevin Harreld

Project Editor:
Jenny Davidson

Series Technical Editor:
Michael D. Sullivan

Interior Layout Tech:
Bill Hartman

Cover Designer:
Mike Tanamachi

Indexer:
Katherine Stimson

Proofreader:
Mike Beady

For product information and technology assistance, contact us at **Cengage Learning Customer & Sales Support, 1-800-354-9706.**

For permission to use material from this text or product, submit all requests online at **cengage.com/permissions**. Further permissions questions can be e-mailed to **permissionrequest@cengage.com**.

All trademarks are the property of their respective owners.

All images © David D. Busch or Rob Sheppard unless otherwise noted.

Library of Congress Control Number: 2012936595

ISBN-13: 978-1-133-60070-1

ISBN-10: 1-133-60070-0

Cengage Learning is a leading provider of customized learning solutions with office locations around the globe, including Singapore, the United Kingdom, Australia, Mexico, Brazil, and Japan. Locate your local office at: **international.cengage. com/region**.

Cengage Learning products are represented in Canada by Nelson Education, Ltd.

For your lifelong learning solutions, visit **courseptr.com**.

Visit our corporate Web site at **cengage.com**.

Printed in the United States of America
1 2 3 4 5 6 7 14 13 12

Contents

Chapter 1: Quick Setup Guide 1

Chapter 2: Controlling Sharpness 13

Chapter 3: Composition for the Close-Up 29

Chapter 4: Making the Most of Lighting 49

Chapter 5: Changing Focal Lengths 73

Chapter 6: Shooting Tips for Specific Subjects 87

Index 111

Introduction

Throw away your cheat-sheets and command cards! Do you wish you had the most essential information you need to shoot compelling close-up photos using your digital camera's advanced capabilities? We've condensed the basic reference material you need in this handy, lay-flat book, *David Busch's Close-Up and Macro Photography Compact Field Guide*. In it, you'll find the explanations of *why* to use each of your camera's close-up features, and enhance your capabilities with the most versatile accessories. That's the kind of information that is missing from the cheat-sheets and the book packaged with your camera. Everything in this book is written to help you out in the field, as a quick reference you can refer to as you master the full range of things your digital camera can do in the close-up and macro realm.

About the Authors

Rob Sheppard is a photographer and videographer who says his favorite location is the one he is in at any time. He is the author/photographer of hundreds of articles about photography, as well as more than 35 books. Sheppard is a well-known speaker and workshop leader, and a Fellow with the North American Nature Photography Association. He was the long-time editor of the prestigious *Outdoor Photographer* magazine and helped start *PCPhoto* (*Digital Photo*). Presently he is editor-at-large for *Outdoor Photographer*. Visit his website (www.robsheppardphoto.com) and blog (www.natureandphotography. com).

With more than a million books in print, **David D. Busch** is the world's #1 selling digital camera guide author, and the originator of popular digital photography series like *David Busch's Pro Secrets*, *David Busch's Quick Snap Guides*, and *David Busch's Guides to Digital SLR Photography*. As a roving photojournalist for more than 20 years, he illustrated his books, magazine articles, and newspaper reports with award-winning images. Busch operated his own commercial studio, suffocated in formal dress while shooting weddings-for-hire, and shot sports for a daily newspaper and upstate New York college. His photos and articles have appeared in *Popular Photography & Imaging*, *Rangefinder*, *The Professional Photographer*, and hundreds of other publications. He's also reviewed dozens of digital cameras for *CNet* and *Computer Shopper*, and his advice has been featured on NPR's *All Tech Considered*. Visit his website at www.dslrguides.com/blog.

Chapter 1

Quick Setup Guide

Close-up and macro photography offer you the chance to see and share the world around you in ways that can't be explored in any other way. Close-up photography is basically any photography that gives you a closer view of the subject than how people normally see it (as shown in Figure 1.1). This is not simply about distance to the subject because, as you will see later in the book, that is affected by the focal length of the lens you are using.

Macro photography is technically close-up photography of very small subjects so that the size of the subject is the same size in real life as it is captured on the sensor. But that really doesn't have much effect on what you are photographing. Today, macro photography is commonly used interchangeably with

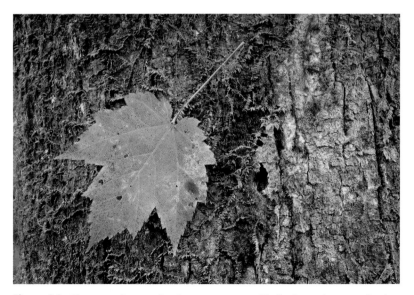

Figure 1.1 Close-ups give you the chance to see a world of color and texture that is not seen from a distance.

close-up photography. This book will give you the field techniques to get you close to your subject and get better photographs, regardless of how people define this type of photography.

Standard Lens Quick Guide

Most lenses for dSLRs and most compact digital cameras will allow you to focus close for close-ups. This is a good place to start. Since the majority of lenses are also zooms, that affects how you will get close as well. Some zooms only allow you to get close at certain focal lengths. Other zooms will not stay in focus when you use the zoom up close and you'll have to refocus. Modern lenses are sharp up close if used carefully. Here are some things you can do to get the best from your lens:

- **Use aperture priority and a mid-range of f/stops.** Your lens will be at its best for close-ups usually between f/8 and f/11. By using aperture priority, you can ensure your lens stays there (Figure 1.2).

- **Be sure your shutter speed is 1/125 or faster.** Up close, any camera movement during exposure is magnified, so you need fast shutter speeds.

- **Use higher ISO settings.** To get a faster shutter speed when you are shooting aperture priority, choose a higher ISO setting for your camera.

- **Set focus then move in.** Too often photographers are too far away from a close subject and the subject does not stand out in the composition. Try setting your lens or camera manually to a close focusing distance, then move in until the subject is sharp.

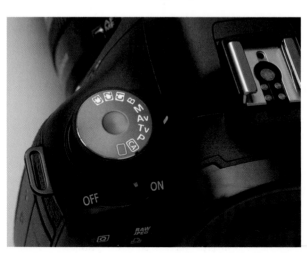

Figure 1.2

Aperture priority is a useful camera setting for close-up work with any lens.

■ **Use a lens shade.** A lens shade is designed to shade the lens from extraneous light to minimize flare. However, it also helps to protect your lens from being hit by leaves, branches, or other objects that you don't see as you get close.

■ **Keep steady.** Hold your camera steady and never punch your shutter button in order to get the maximum sharpness from your lens. Or, use a tripod or activate your camera or lens's image stabilization/vibration-reduction feature.

Macro Lens Quick Guide

Macro lenses for dSLRs allow you to focus from infinity to true macro distances. They can be an excellent tool for capturing close-ups, especially very small subjects (as shown in Figure 1.3), but you do not need a macro lens in order to do close-up photography. You will learn more about using all lenses for close-ups and why you may want to shoot with other lenses in Chapter 5. But here are some things you can do to get the best from a macro lens:

■ **Use aperture priority and any f/stop.** Macro lenses are designed to have high sharpness up close with any f/stop. By using aperture priority, you can ensure your lens stays on a wide f/stop for limited depth-of-field or a small f/stop for more depth-of-field or sharpness in depth from close to far.

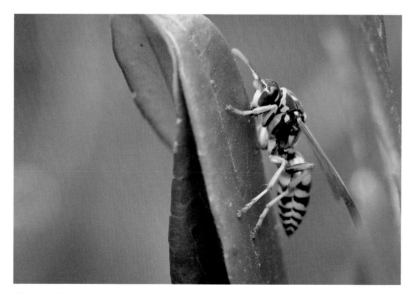

Figure 1.3 Get in close with a macro lens—they are designed to work well for very small subjects.

- **Be sure your shutter speed is 1/125 or faster.** Up close, any camera movement during exposure is magnified so you need fast shutter speeds, regardless of the type of lens you use.

- **Use higher ISO settings.** This is just as important with macro lenses. Use a faster shutter speed when you are shooting aperture priority with a higher ISO setting.

- **Get in close.** Since macro lenses focus so close, you might not want to set it to a close distance and simply move in. However, remember that your lens does indeed focus close, so start by getting close to your subject.

- **Use a lens shade.** Remember, a lens shade also helps to protect your lens from being hit by leaves, branches, or other objects that you don't see as you get close.

- **Keep steady.** As you get even closer with a macro lens, this becomes even more critical. Hold your camera steady and never punch your shutter button in order to get the maximum sharpness from your lens.

Sharpness Challenges Up Close

The next chapter is devoted to helping you get better sharpness from macro photography. However, there are two immediate challenges to sharp photos—camera movement and limited depth-of-field—that you need to deal with as you prepare to photograph up close. Both are related. The major cause of unsharp and blurry photos for any type of photography is camera movement or shake during exposure. The longer the exposure, the easier it is for the camera to move slightly, and this movement will translate into less sharpness.

With close-up photography, this sharpness challenge is magnified. Consider this: suppose you are shooting a big landscape and during your exposure, the camera shifts a 1/32 of an inch. That's not much compared to that landscape, so you might not notice any difference in the photo. Now think about shooting a subject that is only five inches tall. Now that movement starts to make a big difference. Small highlights will change from dots to short lines; edges of the subject will have a double-vision effect. Your photo will not look as good no matter what lens you use (as shown in Figure 1.4).

Many photographers make a common mistake that causes sharpness problems. A small f/stop or aperture, such as f/16 or f/22, gives more depth-of-field (or sharpness in depth). Since depth-of-field is severely limited the closer you get to your subject, it would seem logical to simply use a small f/stop. But using a small f/stop means you also have to use a slower shutter speed. A slower shutter

Figure 1.4 Camera movement during exposure is a major cause of unsharpness with close-up photography.

speed makes it more likely you will have camera movement. So while f/16 might mean you have more depth-of-field, it might also mean nothing is really sharp because of camera movement.

Another problem with these sharpness challenges is that they often do not show up on the camera's LCD after you take the picture. The screen is simply too small to show you the fine detail that has been compromised unless you are willing to enlarge that screen and scroll around it. With a close-up, that can be challenging to do in the field. Don't make the assumption that your photo is sharp just because it "looks" sharp on the LCD.

Shutter Speed and Close-Ups

Using a faster shutter speed as noted in the quick guides in the first part of this chapter will help you minimize camera movement. The camera cannot move much during exposure if the shutter speed is short. This is especially critical for hand-holding the camera and much close-up work is done hand-held. When the camera is not stabilized by a tripod, there is much more opportunity for it to move during exposure.

Here are some things to consider when you are choosing your shutter speed when hand-holding your camera for close-ups:

- **Close-ups magnify the subject and camera movement.** The closer you get, the faster the shutter speed you need to eliminate camera movement (Figure 1.5). Don't be seduced by the idea of more depth-of-field if that small aperture means your shutter speed is too slow.

- **Consider 1/125 second your slowest shutter speed.** When you are close, you will find that any shutter speed slower than 1/125 second will cause you consistent sharpness problems.

- **Test your ability to hand-hold close-ups.** Find a close-up subject with good detail, then photograph it at a variety of shutter speeds. Examine the results carefully by magnifying the photo on your computer. Notice what happens to small highlights (they should be points of light, not lines) and how edges are affected.

- **Shoot at 1/250 or faster for any telephoto close-ups.** Telephotos really magnify much more than the subject, and up close that causes challenges with camera movement during exposure.

Figure 1.5 The rock details here need to be sharp, so a wide aperture was used to keep the shutter speed fast. Any camera movement during exposure is magnified the closer you get to your subject.

■ **Choose your f/stop and adjust your ISO for shutter speed if needed.**
Choose an f/stop for what you want from the photo, whether that is a wide
f/stop like f/4 for a shallow depth-of-field effect, or a small f/stop like f/16
for more depth-of-field. Then check your shutter speed. Use a higher ISO
if the shutter speed is not fast enough.

ISO and Sharpness

ISO settings control the sensitivity of your camera to light. A high number
means the camera is more sensitive to the light, which allows you to shoot in
lower light with faster shutter speeds, for example. A low number means the
camera is less sensitive to light, which allows you to shoot with smaller f/stops
and faster shutter speeds in bright light. So ISO affects how you work with
close-ups. You may need to use a higher ISO in order to use a faster shutter
speed to minimize camera movement or in order to use a smaller f/stop com-
bined with a faster shutter speed if you have enough light.

The challenge with ISO is that higher settings also result in more noise in the
photo. Visual noise is a sand-like pattern that goes across the photo and is most
noticeable in continuous tone and out-of-focus areas, both of which are more
likely to be seen in close-ups. So while you have learned that setting a higher
ISO can help you get a faster shutter speed when you need one for close-ups,
this also comes at a cost—noise. Noise can be very distracting in a photo and
it can disrupt tonalities and colors, making them less attractive.

So if higher ISO settings are good for sharpness, but bad for noise, what can
you do? Here are some things to consider:

■ **Expose properly.** Underexposure is a real problem for noise, no matter
how good your camera is at controlling noise. Even if you do not know
much about reading a histogram, you can look at it and see underexposure
immediately if you look at the right side. There should be no large gap
there.

■ **Minimize your use of very high ISOs.** With modern dSLRs, you can
shoot from ISO 100–400 without getting much noise. Noise becomes
increasingly apparent as you go above ISO 800. How strong it will be
depends on your camera and how much you enlarge your images.

■ **Standardize your use of ISO.** Rather than constantly changing your
ISO, set it at 400 for most close-up work and leave it there. That is a high
enough ISO to allow fast shutter speeds, yet it is low enough that noise is
not a big problem with most cameras.

- **A sharp photo can be more important than added noise.** Never hesitate to use a higher ISO if it means the difference between a sharp photo (because you can use a faster shutter speed) and a "soft" or blurry shot (as shown in Figures 1.6 and 1.7).

- **Consider the sensor size.** Smaller sensors tend to produce more noise (though newer technologies make this less true). You can often get away with much higher ISO settings with a larger sensor. Full-frame 35mm is larger than APS-C, which is larger than Four Thirds, which is larger than most compact and point-and-shoot camera sensors. Sensor size also affects depth-of-field indirectly, because cameras with smaller sensors use lenses with shorter focal lengths to produce the same field of view.

Figure 1.6

A sharp photo with noise from a high ISO is better than a fuzzy photo shot without noise.

Figure 1.7

Detail of Figure 1.6 showing noise and sharpness.

Camera Handling for Close-Ups

Since close-up photography is so sensitive to camera movement during expo-
sure, how you hold your camera really does make a difference. This is affected
both by how the camera sits in your hands as well as how you press the shutter.
A common way you will see people holding a dSLR is with hands at the sides
of the camera—this causes the camera to want to tilt down from the weight of
the lens so correcting for that causes camera movement. Another common way
a camera is held is with the right hand holding the right side of the camera and
the left hand palm down holding the lens from above. Again, there is a ten-
dency for the camera to want to move up and down from this technique. Here
are the steps to follow to ensure that your dSLR camera is as stable as possible
when you squeeze the shutter:

1. Turn your left hand palm up.
2. Place the camera onto your left palm so that the fingers can go around the
 lens (as shown in Figure 1.8). The camera should be balanced so it is not
 tilting down.
3. Hold the right side of the camera with your right hand, with your point-
 ing finger over the shutter button.
4. Bring your elbows into the sides of your chest. If you are close to the
 ground, you can put your elbows on the ground for support or against a
 knee or anything else that can help stabilize the camera.
5. Bring the camera up to your eye to look through the viewfinder.

Figure 1.8

Support your
camera with your
left hand palm up
so it can cradle
the lens.

6. If you are using live view to focus and view your subject, keep your elbows against your chest and look down slightly to use the LCD. Avoid extending your arms out with the camera in hand as you shoot.

7. Squeeze the shutter button firmly down, but never punch or jab at the button (a sure way to cause camera movement).

Holding a compact digital camera is similar. It is so tempting to hold a small, light camera with one hand, but that will cause you problems, especially with close-ups. The mass of these cameras is so small that the slight pushing of the shutter will cause unwanted camera movement. Two hands dampen that. Here are the steps modified to work with these cameras where you are almost always going to use a live view with the LCD:

1. Hold the camera comfortably with two hands. If the camera is big enough, you will get more support if you can put it into a palm-up left hand (as shown in Figure 1.9).

2. Hold the right side of the camera with your right hand, with your pointing finger over the shutter button.

3. Once again, bring your elbows into the sides of your chest. You can also brace your elbows against anything nearby for support to help stabilize the camera.

4. Keep your elbows against your chest and look down slightly to use the LCD. Avoid extending your arms out with the camera in hand as you shoot.

5. Squeeze the shutter button firmly down, but never punch or jab at the button (a sure way to cause camera movement).

Figure 1.9
No matter what camera you use for close-ups, hold your camera with two hands.

The White Balance Challenge

Auto white balance is convenient and easy to use. The problem is that it is inconsistent in results and tends to give a bluish cast to many outdoor subjects. Such inconsistency can definitely be a problem up close. Auto white balance is designed to constantly change as the camera "thinks" the light changes. When you are up close, even a slight change in angle to the subject can change enough of the overall subject and background, as well as their relationship to the light, that the camera gets fooled and changes the white balance when it should not be changed. The result is that the colors of your subject change, even though it has actually not changed at all. Plus the blue cast will make your colors less saturated. That can be frustrating and will mean more work for you in the computer. Here's how to avoid this problem:

- **Choose a specific white balance.** As soon as you set a specific white balance, the camera will respond in a consistent way to every shot.

- **Select a white balance appropriate to the conditions.** If your subject is in the sun, choose Daylight for the white balance (Figure 1.10). If your subject is in the shade, choose Shade. Try to match the white balance setting to the light.

- **Try a white balance that warms the subject.** An alternative option is to warm up the subject by choosing a white balance warmer than the conditions, such as Cloudy for sunlight. This can be quite effective when the sun is low, but be aware that some cameras can give an annoying color cast when you do this during midday sun.

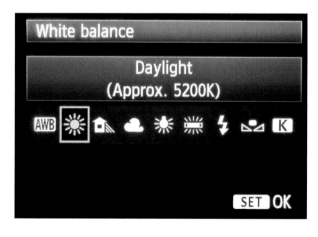

Figure 1.10

Choosing a specific white balance can make your colors more saturated and more consistent.

■ **Use custom white balance for very accurate colors.** If colors must be recorded in a certain way, custom white balance is the best way to do this. Unfortunately, camera manufacturers have not standardized how this is done, so you will have to consult your manual for instructions on setting a custom white balance for your camera.

Chapter 2

Controlling Sharpness

In the last chapter, you learned about the basics of shooting close-ups and macro images. That included information about sharpness as related to camera movement during exposure. Certainly you want to minimize camera movement, because that is going to ensure that you get the sharpest pictures possible. But sharpness up close is much more than controlling that potential problem. How you control sharpness up close can really make a big difference in your final results.

There are three reasons why sharpness is such a big deal when you are shooting up close:

- **Depth-of-field is very shallow (Figure 2.1).** No matter what you do, depth-of-field is limited, so if you miss your focus point by even a fraction of an inch, your photo will look out of focus.

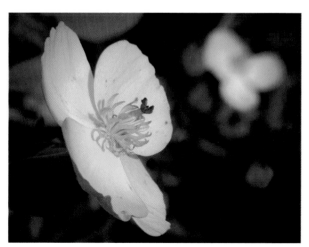

Figure 2.1
Depth-of-field is limited when you photograph up close, no matter what you do.

- **Many places compete for focus.** When you are up close, you will typically find that there are many parts of your subject that could be sharp, yet you won't always be able to keep them all in focus. This competition for sharpness can lead to the wrong spot being in focus.
- **Close-up distances magnify camera movement.** This was covered in the first chapter because it is part of the basic approach to close-up photography. It is key to remember that even a slight movement of the camera during exposure can have a big effect relative to the small area you are photographing. That can lead to problems with sharpness.

Working with Depth-of-Field

Depth-of-field or sharpness in depth declines dramatically the closer you get to your subject and your focus point. Many photographers know that small f/stops such as f/16 give more depth-of-field and will choose these f/stops for work up close. That is not always the best decision. It helps to understand what influences depth-of-field and how you can control it in order to choose the proper f/stop and way of photographing your subject.

Depth-of-field is controlled by three basic things:

- **Distance to the subject.** Back up from your subject, and depth-of-field increases. Move in closer to the subject and depth-of-field decreases. Depth-of-field can go down to a fraction of an inch when you are at true macro distances of inches away from your subject.
- **Aperture or f/stop.** Small f/stops such as f/16 increase the amount of depth-of-field, as shown in Figure 2.2, although it is still limited when you are up close. Large f/stops decrease the amount of depth-of-field, as shown in Figure 2.3.
- **Focal length.** Wide-angle lenses or short focal lengths will give more depth-of-field, as shown in Figure 2.2. Telephoto lenses will give less depth-of-field, as shown in Figure 2.3. This applies to close-ups the same as when you are shooting more distant subjects. Because small sensor cameras use wider or shorter focal lengths for the same angle of view, they will usually result in increased depth-of-field.

Changing your distance to the subject is not something that you have a lot of control over when you are doing close-ups. Basically you are getting close to your subject and that's part of the whole appeal of close-up photography. But it's important to realize that as you get close, you will have limitations with depth-of-field. You can choose both aperture and focal length to affect depth-of-field so it is important to think about them when you are doing close-up work.

Figure 2.2 A small aperture such as f/16 with a wide-angle lens will have a deeper depth-of-field.

Figure 2.3 A wide aperture with a telephoto lens will have a shallower depth-of-field, which can help your subject stand out.

Choosing f/stops

Apertures or f/stops are an especially important choice to make for close-up photography. An f/stop refers to the size of the opening inside your lens that lets light through the lens (Figure 2.4). It affects both depth-of-field and your shutter speed choice, both of which affect sharpness. This is why you will find it beneficial to shoot with aperture priority or manual exposure because in both cases, you can choose a specific f/stop. Program (P) and shutter priority (S or Tv) exposure will continually change your f/stops—you'll never know exactly what you get.

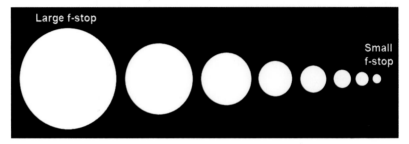

Figure 2.4 Apertures or f/stops range from large to small.

Aperture choice can be a little confusing because the numbers don't intuitively match the size of the opening. Small numbers result in a wide opening for the aperture, such as f/2.8 or f/4, and large numbers result in a small opening for the aperture, such as f/16 or f/22. (The reason for this is that apertures are a fraction even though they don't display that way on your camera.) Wide openings—small numbers—allow the maximum amount of light through the lens (Figure 2.5). Small openings—big numbers—allow much less light through the lens (Figure 2.6). Wide openings result in less depth-of-field and small openings produce more depth-of-field. One way to think of that is that small numbers provide less depth-of-field and large numbers offer more depth-of-field.

Depth-of-field is not just about something being sharp or something being out of focus. When you are doing close-ups, what this will mean is how defined and recognizable things are behind and in front of your subject. More depth-of-field doesn't necessarily mean that your background will be sharp, but it will become more defined and either complementary to your subject or distracting for your photograph.

Figure 2.5 A small number, such as f/2, gives a wide opening inside the lens.

Figure 2.6 A large number, such as f/16, gives a small opening inside the lens.

Here are some things to think about when you are choosing f/stops for depth-of-field:

- **Wide f/stops I (f/4, f/2.8, f/2).** Use wide f/stops when you need your background to be out of focus. This will make your background have a maximum amount of unsharpness and can really help your subject stand out because of its contrast in sharpness. Sometimes this contrast in sharpness makes your subject look even sharper compared to a photo where the background is more in focus even though the subject is just the same.

- **Wide f/stops II (f/4, f/2.8, f/2).** Choose wide f/stops when you need a fast shutter speed to make sure that you don't have camera movement during exposure.

- **Small f/stops (f/16, f/22).** Select a small f/stop when you need as much depth-of-field as possible. This will give you more sharpness around your subject as well as more sharpness in the background.

- **Small f/stop risk.** Remember that when you choose a small f/stop with aperture priority, your camera will automatically select a slower shutter speed. Pay attention to that shutter speed so that you are not shooting at such a slow shutter speed that you get camera movement during your exposure.

- **Beware of the smallest f/stops.** On many lenses, the smallest apertures are so small that they cause a problem called diffraction. This means that the light diffracts or changes as it goes through that small opening. This can create a softness to the image. Do a test where you shoot a subject with your smallest apertures and make a comparison to see if there is a problem.

■ **Don't be afraid of wide open.** Because depth-of-field is so limited up close, many photographers just use small apertures. Yet when you shoot with your lens wide open, at the widest possible f/stop, you can get some interesting effects that are simply not possible in any other way. You will have very strong out-of-focus backgrounds that, with the right focal length, can offer wonderful colors and tonalities. You also affect out-of-focus highlights so that they take on circular shapes.

Depth-of-Field and Focal Length

As mentioned in Chapter 1, close-up and macro photography are not just about using a macro lens. By using other lenses, you change focal lengths and that can have an effect on your image. This will be discussed in detail in Chapter 5. However, the effect of focal length on depth-of-field is so strong that it needs to be included here as well.

This change is so significant that even zooming a lens will change your depth-of-field. Since depth-of-field is so closely associated with f/stops, many photographers think that if they set an f/stop at a particular point, depth-of-field doesn't change even if they change their focal length by zooming. That's simply not true. Since wider angle focal lengths will give you more depth-of-field, zooming your lens out to a wider focal length will also give you more depth-of-field. Since a telephoto focal length will give you less depth-of-field, zooming your lens again toward a telephoto focal length will do the same.

Choosing the Focus Point

Since your depth-of-field is so narrow when you are shooting up close, you cannot take for granted where your focus point will be in your picture. Your focus point is going to be the sharpest part of your picture. A slight change in that focus point can truly make the difference between a picture that grabs your viewer's attention and one that people pass on by.

It also takes some thought to know what part of the subject or image will look best as the sharpest part of the picture. At first, this will mean a little extra time when you are taking pictures. With some experience, you will find that you will start doing this quickly and automatically. Here are some ideas for you to consider about focus point:

■ **What is key to your subject?** As you move in close, you will see that certain parts of the subject are definitely more important than others. These will vary depending on the subject, but if you look for this as you focus on your subject, you will find things that definitely stand out as being more important.

- **What is most understandable?** Sometimes you will find that a part of the subject is so clearly defined by contrast or light that it makes the image more understandable. That is definitely something to focus on.

- **Focus on the eyes.** If you are photographing insects or other small creatures, be sure that the eyes are sharp (Figure 2.7). If the eyes are not sharp, the image will look like it is out of focus even if another part of the body is sharp.

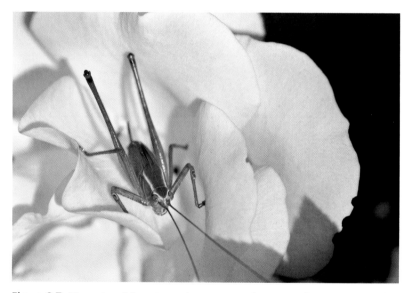

Figure 2.7 The point of focus is very important to close-up work. For insects and other small critters, be sure to focus on the eyes.

The Autofocus Challenge

Autofocus (AF) is a wonderful tool for photography. It helps your camera focus quickly and easily so that you don't have to worry about always focusing on your subject. It has helped photographers get sharper pictures over the years because there is less of a problem with focusing being way off. Except for close-ups.

Close-up and macro photography cause some real challenges for autofocus. The main reason for that is simply the narrow area of focus that you have to deal with. When you are up close, there are often many places where the camera could focus, yet very few of them will give you the best point of focus. Autofocus will choose where to put the point of focus rather arbitrarily and it won't always be in the right place.

At best, autofocus might just miss the focus point slightly. At worst, AF might completely miss anything that is near your subject and start focusing on the background. Regardless, autofocus will often constantly search to find focus when you are up close. This can be annoying and time-consuming. Here are some things you can do when using AF up close to minimize these problems:

- **Lock focus.** On almost all digital cameras, you can lock focus by pressing the shutter button lightly without pushing it so far as to take the picture. Some cameras also have a specific focus lock button. Locking focus will keep the camera from constantly searching to find a focus point.

- **Limit focus.** On most macro lenses, you will find a focus limiting switch. What this does is limit your range of focus to a specific distance so that the camera is not constantly searching all the way to infinity to find focus for a close-up.

- **Move the camera to focus.** Once you have locked focus, you still might not have the camera focused on the correct focus point. Keep focus locked and smoothly move the camera toward and away from the subject until you see the correct focus point become sharp.

- **Try continuous shooting with a moving subject.** Wind can be a problem with subject movement so that it can be hard to hold focus on the subject. Set your camera to continuous AF and continuous shooting and then simply hold your shutter button down as you keep moving slightly to stay with the subject. You will find that at least some of your pictures will have the right sharpness (Figure 2.8) and you can throw out the rest.

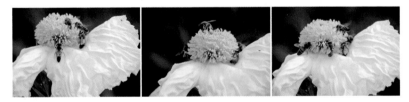

Figure 2.8 Set your camera to continuous shooting when you are dealing with a moving subject and shoot multiple shots of your subject.

Manual Focus

Manual focus can be the best way to deal with close-up sharpness. All dSLR lenses can be manually focused, and many compact cameras also allow manual focus. With manual focus, you are in charge of choosing where to put your focus. It can still be challenging for close-ups, however.

One thing that throws off a lot of photographers is that as you change focus with a lens at very close distances, you are doing more than changing where the focus point is. Because of the way optics work, you are also enlarging or reducing the size of your subject as you focus. This can make focusing much harder. Here are some steps to work with manual focus and close-ups:

1. **Set a focus.** Get in close to your subject and set at least a rough focus on your subject based on how you want the subject to appear in your shot. Then leave your focus ring alone.

2. **Move the camera to focus.** With your focus now manually set, smoothly move the camera toward and away from the subject until you see the correct focus point become sharp (Figure 2.9). Remember to leave your focus ring alone and do not try to focus the lens in that way.

3. **Try continuous shooting.** Because the area of sharpness is so limited, it can sometimes be hard to hit that perfect focus point. By setting your camera to continuous shooting and then moving your camera as you focus, you will usually get several sharp images that are sharp exactly where they need to be.

4. **Use continuous shooting with a moving subject.** Wind can be a problem with subject movement so that it can be hard to manually focus on the subject. Set your camera to continuous shooting as in step 3 and then hold your shutter button down as you move to stay with the subject.

Figure 2.9

Manual focus can be a good way of focusing up close. Get close to your subject, set a focus, and then move the camera for the final focus point.

Using Your Camera Angle for Sharpness

The limited depth-of-field that you are working with up close is actually a plane of sharpness that parallels the back of your camera. As you tilt your camera down, for example, that plane also tilts down. If you tilt the camera up, the plane also tilts up. This plane will also swivel left or right as you swivel the camera left or right, too.

You can use this information to help you refine sharpness on your subject. As you look at your subject, you will often notice that the important parts of that subject are in a plane. For example, a group of flowers will have its important parts in a plane that goes through the key flowers for the photo. Therefore, to get more of those flowers sharp, tilt or turn your camera to move the plane of your camera parallel to the plane of the important parts of the flowers (Figure 2.10). That puts the plane of sharpness right through that area of the flowers.

You can also use this information to help you get better out-of-focus backgrounds. When photographers shoot a close-up subject that is close to the ground, they often tilt the camera down toward that subject. The result is that the background, the ground itself, is not all that far away from the subject. Because of this, that background will often be distracting because it shows too much detail.

Figure 2.10 By keeping the back of the camera parallel to these flowers, most of them stay in focus even though depth-of-field is narrow.

By changing your angle to the subject, by getting down low and shooting directly at the subject, as shown in Figure 2.11, you can change the distance of any background behind your subject. If the ground was the background before, now you will no longer see the ground and you will see things that are above the ground or at some distance away in the background and these will be more out of focus. Or you can simply move around to change how close things are behind your subject and change how strong that background will appear behind your subject.

Figure 2.11 A low angle to your subject can make the background less in focus.

Using Live View

Live View is a function of a digital camera that allows you to display live on your LCD what your lens is seeing. Normally on a dSLR, the LCD is blank as you shoot. This is because there is a mirror inside your camera that is projecting what the lens sees through to your viewfinder. When you take the picture, that mirror flips up out of the way so that the light from the lens can go directly to your sensor. With Live View, the light is going directly to your sensor and the image that is captured by the sensor is sent to your LCD. Compact digital cameras always show a Live View LCD. Of course, mirrorless interchangeable lens cameras, and "translucent" mirror models like the Sony SLT line are able to show a "live view" all the time.

Live View is a very useful tool for close-up and macro photography. Here's what it can do for you:

- **Focus aid.** On nearly all dSLRs, you can magnify the view in Live View (Figure 2.12). This allows you to focus on details of your subject displayed on your LCD that can be difficult to otherwise see. For some subjects this can be really helpful.

- **Mirror up.** When you are shooting a close-up from a tripod and at certain slow shutter speeds, the movement of the mirror in a conventional SLR, called mirror balance, can cause camera movement during exposure and unsharpness for your picture. Some cameras allow you to lock the mirror up to prevent this (and others don't have a mirror at all). However, when you are shooting with Live View on a dSLR, the mirror is already up and you don't have this problem.

- **Camera closer to some subjects.** Some close-up subjects can be quite skittish when you bend down and stick your head and camera close to them. You may also find subjects that look to be very interesting to photograph, but you and your camera simply cannot fit into the space. Yet, a camera alone might. Either way, you can hold your camera out close to the subject, away from your head and shoulders, and frame your subject with Live View.

- **White balance display.** Live View always shows you exactly what the sensor is capturing, including white balance. This can quickly give you an idea if your white balance is correct or not.

Figure 2.12
Live View can be magnified on most cameras in order to better focus on your subject.

Tripods for Sharp Close-Ups

For ultimate sharpness, a tripod can't be beat. A tripod holds your camera steady to limit or even eliminate camera movement during exposure. You can't always use a tripod for close-up work for a variety of reasons, but when you can, you will help to ensure sharpness. For one thing, it will allow you to use slower shutter speeds that cannot be hand-held at all. That can permit you to choose smaller f/stops for more depth-of-field or to shoot when the light level is low.

Choosing and using a tripod for close-ups is different from choosing and using a tripod for other purposes, whether that be shooting landscapes, architecture, or even portraits. Here are features to look for when choosing a tripod for close-ups and macro work:

- **Spreading legs.** You should be able to unlock the angle of the legs of a tripod and spread them out as shown in Figure 2.13 so that you can make the height of the tripod lower. This also helps you shoot on uneven surfaces.

- **Inverting center column.** With many tripods, you can take the center column out, flip it over, and then put it in upside down. This then puts the tripod head between the legs and allows you to position the camera very low to the ground, although it will be upside down.

- **Tilting center column.** On some tripods, you can tilt the center column so that it goes off to one side or even drops below the level of the top of the tripod. This will also allow you to get the camera closer to many subjects.

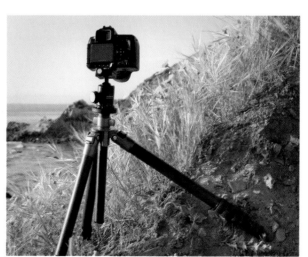

Figure 2.13
When you can spread your tripod's legs, you can get it lower to the ground and have it work better on uneven surfaces.

- **Removable center column.** Some tripods allow you to remove the center column and mount the tripod head directly to the top of the legs. This is done for tripods that allow a great deal of spread with the legs so that the center column does not get in the way as you drop the height of the tripod.

- **Ballhead.** Ballheads for a tripod tend to work best for close-up work because they have so much flexibility for adjusting your camera level compared to other types of heads.

Other Camera Support for Sharper Close-Ups

A tripod is not the only way to hold your camera steady for close-ups. Beanbags, monopods, and special attachments for the tripod will assist you in getting sharper pictures because your camera is well supported.

Beanbags

Beanbags are small, lightweight bags that are filled with a material that changes its form so that you can put the bag under your camera and the bag then molds to the shape of the camera for support (Figure 2.14). Beanbags get their name because originally they were bags filled with beans. Today they tend to be filled with things like plastic pellets because beans can absorb moisture. Some photographers will travel with empty beanbags and look for easily purchased beans when they arrive at their location. Because they don't keep the beans, there is not a problem if they get wet.

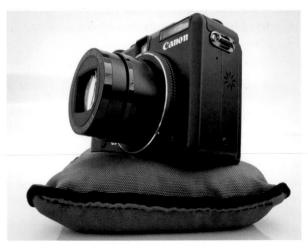

Figure 2.14
A beanbag is a simple, lightweight, and highly portable camera support.

Here are some things you can do with a beanbag to help you get better close-up photography:

- **Carry a beanbag when you need to go light.** Sometimes it is just hard to carry a tripod, but at least with a beanbag in your camera bag, you always have the potential for support.

- **Use it on the ground.** Get a very low angle close-up by putting the beanbag on the ground and then the camera on the beanbag.

- **Place it on a sturdy object.** Put a beanbag on a rock, against a tree trunk, on a table, or anything that is sturdy and then put your camera on the beanbag.

- **Use it against your tripod.** Sometimes the simplest way to get a camera down low and supported is to use your tripod, but also use a beanbag. Hold your beanbag against your tripod leg and then the camera against the beanbag for a stable support. Some photographers also carry small clamps to attach a camera to the tripod for the same purpose. The clamp is more stable, but also can be more challenging to use.

- **Put it against your knee.** Sometimes you can use your lower leg as a support, but it can be awkward holding the camera against your hard knee or shin. The beanbag helps mold the camera against your leg bones.

Monopod

A monopod is like a single leg of a tripod (Figure 2.15). Since there is only one leg, you don't get the support of a tripod, but you also have a much lighter and easier to carry piece of gear. It can definitely help you get sharper movements by supporting the camera enough to allow slower shutter speeds to limit camera movement during exposure. A tripod will let you use even slower shutter speeds, but a monopod will help.

In addition, a monopod can be much easier to use in situations where there are a lot of obstacles such as branches and twigs around your close-up subject. It is easier to set up one leg than three in those situations. In addition, with a monopod you can more easily move your camera around to get the shot and for getting a better focus point.

Monopods are typically sold without a head. It is important that you get at least a small ballhead for your monopod or you will find it difficult to level your camera in many situations. Without a head, you will also find it impossible to do vertical shots.

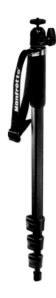

Figure 2.15
A monopod is a highly portable camera support. Be sure to get a head for it.

Focusing Rail

A focusing rail is a specialized piece of close-up gear that helps with precise focus. This is attached to your tripod, then the camera is attached to it. The focusing rail has sliding plates to allow you to position your camera forward and backward as well as side to side. Knobs rotate to control the gears that move these plates. A focusing rail can be hard to use outdoors if there is any wind, but for indoor work, it allows a very precise positioning of the subject for focus and composition.

The Value of Image Stabilization

Many lenses today come with image stabilization. You'll also hear terms like vibration reduction, optical stabilization, vibration compensation, and so forth. All of these things mean essentially the same thing; there is a lens or sensor compensating mechanism that moves to balance any movement of the camera during exposure. In a sense, this new movement in the lens or camera cancels out the movement of the camera itself during exposure. This can help you gain significantly sharper pictures with slower shutter speeds.

Image stabilization is a great help for close-up work when you're shooting hand-held. It should not be used when you're using a tripod, although it can help when you are using a monopod. It will only help you gain a few EV steps of slower shutter speed, but sometimes that is enough to give you a sharper picture.

Chapter 3

Composition for the Close-Up

When photographers discuss composition, they are often referring to how they work with landscape photography. There is a long tradition of discussion about how to compose a landscape image that started way before photography. Landscapes have long been a great subject for talking about composition because the landscape stays in place and allows the photographer to consider many things about how to organize the image within the photograph. This is not so true for close-ups.

Composition is about organization of your photograph. Composition is not talked about as much for close-up and macro photography simply because the subject is often so dramatic. Having beautiful subjects enlarge before your eyes as you get in close to them is definitely a great part of the experience. However, that can also be a distraction. That good-looking subject is not a photograph and it cannot be physically put into the photograph. A photograph is an interpretation of the subject and because of that, composition is very important.

Composition can be seen as three things, as shown in Figure 3.1:

- **Arrangement.** Composition is how you arrange the visual elements of your photograph, from the subject to the foreground and background to the edges to the corners and so forth.
- **Definition.** A composition defines what we see of the subject and how it is presented to the viewer.
- **Communication.** Ultimately, composition is about communicating something about your subject to the viewer of your image. Good composition is clear and direct communication.

Figure 3.1 Composition is about organizing the picture elements of your photo so that they are arranged attractively, they define the subject and the photo, and they communicate something about the subject.

Focus on the Photograph, Not Just the Subject

With that stunning macro subject, remember that you are making a photograph, not simply capturing a subject. If you are a scientist documenting a new species of beetle, then the subject may be more important than the photograph itself, but even then, the composition concepts of arrangement, definition, and communication are still important.

A problem develops when you start thinking that you have a beautiful subject and all you have to do is point a good camera at it and you will have a good photo. Photography doesn't work that way. A beautiful subject such as a rose is wonderful to behold in real life, but it does not exist in the same way when it is put into the confines of a photograph. Three dimensions have been reduced to two, the subject is isolated from the world, no other senses are involved, and so forth.

That flower becomes part of a good photograph when you start looking at the image itself, not simply seeing if the flower is framed inside the edges of the photo. As a digital photographer, you have a distinct advantage over

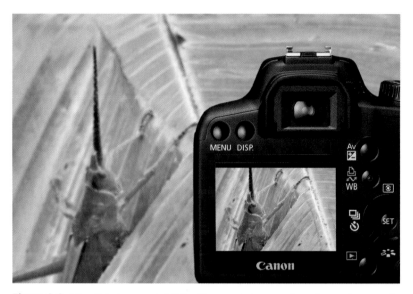

Figure 3.2 The digital camera's LCD offers a truly instant view of your photograph.

photographers of the past—your LCD gives you an instant view of the photograph that the camera is taking (Figure 3.2).

Here are some things that can help you better use the LCD for better composition:

- **Look at your LCD as a miniature photograph.** Use the LCD as more than a confirmation of where you pointed the camera, but also as a little display of a photograph. Do you like the image?

- **Change your display time.** Press the shutter release and your photo will appear on your LCD screen for a brief time. Cameras typically are set to display this review for way too short a time. Go into your camera's menus and set the Review Time to 8 seconds or longer. This is long enough that you will get an idea of what your picture actually looks like.

- **Shade your LCD.** Yes, the LCD can be hard to see in bright light, so shade it with your hat or a hand.

- **Magnify your image.** This is really important for close-up work since depth-of-field is so narrow and it is easy to miss the key focus point. Focus point does affect composition because it changes the way a viewer looks at the photo.

- **Get a magnifier.** A number of manufacturers make magnifiers with light-blocking housings so you can put them on the LCD for a clearer and more magnified look at your subject and composition (Figure 3.3).

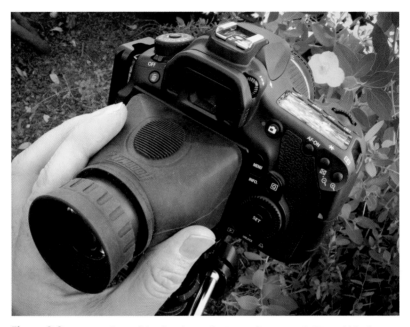

Figure 3.3 A magnifier will both enlarge the image from your LCD and block extraneous light to make it easier to see LCD image details.

Planning Your Shots and Angles

One of the great aspects of close-up photography compared to normal photography is that your subject is small enough that it is easy to move around it. This means you can change your angle to the subject quite easily. Changing the angle of your camera to the subject affects composition, light, plane of focus, background, foreground, and so forth.

When photographers first start doing close-ups, they often shoot with the same identical angle, camera pointed down at the subject at about a 45-degree angle. This can be a perfectly fine angle, but it can also be very limiting. Subjects don't always look their best when you are looking down on them. Sometimes the subject will look better when the camera is below it, or "eye-level" to a grass flower (Figure 3.4). Sometimes the subject will look its best when you are vertically directly over it. The point is that there should be no arbitrary angle to your subject that you always use. It is just too easy to change that angle for close-up work.

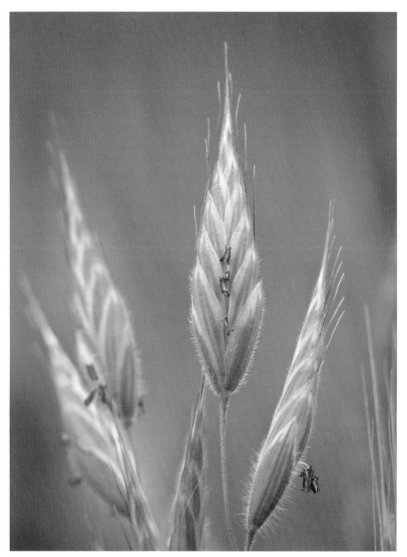

Figure 3.4 By getting down to the level of your close subject, your photograph will be more original than the standard 45-degree angle shot.

Watch That Background

The background for your subject is extremely important for close-up work. So often photographers think that because the background is out of focus, it is no longer as important. That is simply not true. The background is always important, and when it is forgotten, you will often end up with distractions that hurt your photograph, as seen in Figure 3.5.

One challenge that you will face as a close-up photographer is that what you see through your viewfinder is not exactly what the camera is going to capture. While focusing, your camera sets your lens to its widest aperture or f/stop. This makes focusing easier because depth-of-field is at its narrowest. But that also makes the background look more out of focus. When you take your picture, the lens stops down to the taking aperture so that you will have more depth-of-field. Even if the background does not become sharp, it will become more defined, and it is that definition that can highlight distractions that you don't want.

One thing that can help is to use the depth-of-field preview button or lever if your camera has one. If you're looking through the viewfinder, this will make your image look very dark so that it can be hard to see what is happening in the background (though with experience, you can learn to do it). If your

Figure 3.5 A background can still be distracting even when it is out of focus.

camera has Live View, then using the depth-of-field preview lever works quite nicely because you see how sharpness changes and the image will stay bright on your LCD.

As you examine your background behind your subject, and you can do this when you play back your images, too, here are some things to look for:

- **Light.** The light on your subject is important, but so is the light on the background. Any time there is something in the background that is bright away from your subject, you have a distraction. That will always attract the viewer's eye away from your subject. Look for light in the background that complements your subject (Figure 3.6).

- **Contrast.** Contrast in the background can be both good and bad for your subject. Contrast in the background is great when it allows your subject to stand out better against the background. A bright flower against a dark background or a dark object against a white background will help the subject stand out. But when there is something that is very contrasty away from your subject, this will be a distraction and attract your viewer's eye away from the subject.

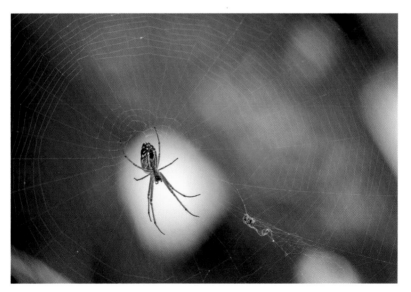

Figure 3.6 By moving just a short distance, a bright spot changes from a distraction to a way of highlighting the subject.

- **Sharpness.** Again, you can help your subject stand out against a background when the background is distinctly out of focus compared to the subject. As you move around your subject, notice that the background will change in distance behind your subject. If you shoot down on your subject, the ground will be much closer behind your subject, and therefore sharper, than if you get lower and discover that things behind your subject are now quite far away.

- **Colors.** It can be very frustrating to have a nice, sharp picture of a close-up subject and discover that there are bright colors in the background that are distracting from it. Colors like red, yellow, and orange are particularly problematic because they will almost always attract the viewer's eye, even if they are totally out of focus.

You will sometimes hear photographers refer to a background blur as having a good or bad bokeh. *Bokeh* comes from boke, a Japanese word meaning blur or haze. Bokeh has become very popular as a way of describing the out-of-focus qualities of your background. This is not different from your out-of-focus background, but it is simply a new term to describe the look.

Working with Foregrounds

Foregrounds are also important to your photography when you are up close to your subject. It is interesting that photographers will often avoid foregrounds when they are up close because they want to be sure to see the subject clearly. You can bend branches down, move flowers out of the way, and so forth. Sometimes that's important to do. Sometimes you don't want to have a foreground; you simply want to see your subject against a simple background.

But foregrounds can also add interesting aspects to your composition (Figure 3.7). A classic way of creating a composition is to layer your image with a foreground then the subject in the middle ground and then the background behind. Foregrounds can add more information about your subject to help your composition communicate better to a viewer. Once again, the challenge the photographer has is to keep that foreground as a supporting element to the image, not the star or a distraction that takes away from your star, the subject.

How you look at and see a foreground is very similar to the way you look at the background, except now you're looking at things in front of the subject. Here are some of the same things you read about for backgrounds, but now changed for getting better foregrounds:

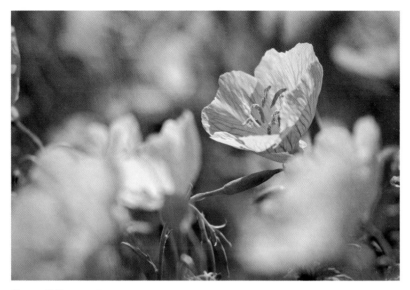

Figure 3.7 With flowers in the foreground and background, this close-up gives an impression of a dense field of flowers.

- **Light.** Once again, the light on your subject is important, but you have to watch what it is doing in the foreground, too. Bright light that breaks up the foreground so that it is less clear as a foreground will cause you problems. Shadows in the wrong places in your foreground can make the picture look very confusing.

- **Contrast.** Contrast in the foreground also works quite well when it allows your subject to stand out better in the image. A dark bit of foliage can act as a frame for a bright flower behind it, for example. Bright foregrounds can be a little harder to work with because they can dominate the composition and make a darker subject harder to see.

- **Sharpness.** A great way to define your composition is to shoot through some objects in the foreground that are totally out of focus. This creates a contrast with the sharp subject that really helps it stand out, as shown in Figure 3.8. This also gives a very different look than having that same contrast in the background.

- **Colors.** Color can be an excellent part of your foreground, especially if it is helping the subject by creating a visual pattern from foreground to subject. That can lead the eye to your subject. Out-of-focus foreground colors can also add an interesting mood or feeling to your photo.

Figure 3.8 An out-of-focus foreground creates a sharp contrast with the in-focus subject, helping the subject to stand out.

One other thing that you can do with foregrounds and backgrounds is to look for visual relationships in your composition. What this means is that you look for something in the foreground that relates to your subject that then relates to something in the background. This can create interesting visual movement of the viewer's eye through the photograph from foreground to background. This could be as simple as a line of mushrooms going from foreground to background on a forest floor or a group of flowers that starts with an out-of-focus flower in the foreground, then a sharp flower, then more out-of-focus flowers in the background.

Isolating the Subject

As you work your subject with foreground and background, you will discover ways of isolating your subject and making it stand out as the star of your composition. As you have read above, backgrounds and foregrounds can cause you problems by adding distractions to the photograph that keep your subject from being the star you wanted it to be in your image. Or they can help by emphasizing the subject.

Isolating your subject in the image can be an excellent way of composing your photograph. This ensures that anyone looking at your image will see and be impressed by the subject just as you were. Sometimes this isolation of the

subject can also create a very dramatic image that has a lot of impact. Here's how to isolate your subject using some of the same ideas you learned from backgrounds and foregrounds:

- **Sharpness.** One of the best ways to isolate your subject in the image is by having the subject very sharp and everything else being totally out of focus, as shown in Figure 3.9. Don't be afraid to shoot with a wide aperture or f/stop (small number) for your lens in order to do this. You'll also find that this effect is strongest when you use a telephoto lens.

- **Contrast.** Contrast is a terrific way of isolating your subject within the image frame. Any time you can put your subject against something that is brighter or darker than it is, you will help define and isolate it within the picture.

- **Light.** A great way to use light for isolating your subject is to find a spot where the light on your subject is very different than the light on the background. When the light is bright on your subject and the background is dark, this acts like a spotlight in a theater to show off your subject.

- **Color.** Colors have contrast and whenever you can use a different color than your subject's color behind your subject, you will help the subject stand out. While it is possible to use a contrasting color in front of your subject, this tends not to work as well for isolating your subject.

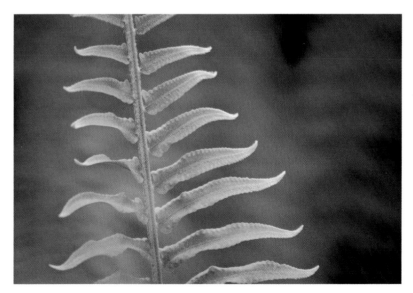

Figure 3.9 A telephoto lens and a wide aperture helped isolate the fern frond subject of this close-up.

Environmental Close-Ups

While isolating a subject is a good and popular way of shooting a close-up, another way of approaching your subject is to look for an environmental close-up. This is like an environmental portrait where a photograph of a person shows both the person and a location. What you're looking for is a way of putting your subject into its surroundings or its environment so that the viewer gets an idea of where the subject lives or is situated.

Both foregrounds and backgrounds are important to an environmental picture. Sometimes you will find that the image will look best with the foreground featured as a part of the setting for your subject; at other times it will be the background, and sometimes you will use both. The key is to look for what can be used as part of the composition that will both show off of the subject and create a relationship between that subject and its setting.

This can be hard to do for close-up photography because there can be so much detail that the composition is hard to understand. The challenge is to create an image that both shows off the subject and its surroundings while still keeping the subject the most important part of the picture. Here are some things to try:

- **Use a wide-angle lens.** Many wide-angle lenses are now designed to focus quite close (Figure 3.10). Set your lens manually to its closest focus distance then move in to see what you can get. When you get close to a subject with a wide-angle lens, the background will shrink while the subject stays big. That can help you define your composition.

- **Choose a small f/stop (such as f/16).** Small f/stops will give you enough depth-of-field to define the setting around your subject. Even though depth-of-field might not cover everything, you will often be able to get the setting defined enough to be understandable.

- **Shoot from a low angle.** When you get your camera down low to your subject, you're often able to reveal the background setting or environment. If you have a tilting LCD on your camera, this can be easy to do. If you don't, put your camera down near the ground and try it anyway. Then check your shot in your LCD to see if you got what you wanted or to see what you need to do to refine the composition.

- **Place your subject carefully.** When you shoot with a wide-angle lens and a small f/stop, you will often have a lot of definition in the detail all around your subject. That can be distracting if it is all right behind your subject. Sometimes you can move just inches and change what is immediately behind your subject so that the subject stands out amongst all of that detail.

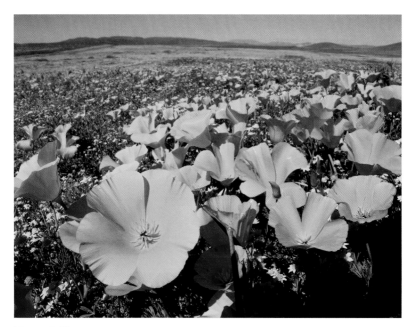

Figure 3.10 When the camera is down low with a wide-angle lens, the environment around your subject is revealed.

The Problem with Centered Subjects

Since close-up and macro subjects can look so dramatic in your viewfinder, it is easy for them to end up in the middle of the image. Photographers focus so much on the subject that they forget about the rest of the image area.

This is a problem because centered images are generally not as effective photographically as when the subject is out of the center of the picture. Researchers have done experiments where they follow the eyes of a viewer as he or she looks at an image. When viewers are looking at a centered image, their eyes stay in the center and they tend to get bored with the image quicker and then move on. When the subject is out of the center, viewers' eyes tend to move all over the image and the viewer will stay with the photograph longer. So it is to your benefit to get your subjects out of the center.

The Rule of Thirds

The rule of thirds is a convenient guide to get your subject out of the center of the image. It is a classic compositional guideline that comes from the art world. It is based on dividing your image area into thirds, horizontally and vertically, with lines dividing each of the thirds. For landscape photography, photographers will typically put the horizon at the bottom third line or the top third line, or a strong tree at one of the vertical lines. Many cameras today include a menu setting that superimposes the rule of thirds over your scene in the viewfinder or over the Live View on your LCD.

In close-up photography, you can use those lines to help you organize your image, plus you can look at the points where the thirds lines intersect (Figure 3.11). They intersect at four points across the image. Each of those points is a very strong position for your subject in the composition. It takes a moment to shift your camera slightly to get your subject out of the center and put it at one of those cross points. But you have to think about it and you have to think about keeping the subject out of the middle of your composition.

Which point do you use? That's really going to depend on your subject and its background (and sometimes the foreground). If you're not sure, take more than one picture with the subject at different places in the frame and see what you like best. That's a good way to learn how to position your subject within the composition.

Figure 3.11 The rule of thirds divides the image into thirds horizontally and vertically. This provides a guideline for subject placement in the composition.

When to Ignore the Rule of Thirds

The rule of thirds really is a guideline and not a rule that has to be followed all of the time. It was developed for the art world originally, so it does present some challenges for the photographer. If you were painting a scene, you could put your subject wherever you wanted because you're starting from a blank canvas. When you're photographing, you are starting with a real world that can't be so easily moved around. And sometimes that real world won't cooperate with the rule of thirds.

So if your subject and its background don't quite fit the rule of thirds, ignore it. But do remember to try to get your subject out of the center. There are other relationships of your subject to the rest of the image that do work besides the rule of thirds.

And sometimes you will want to center your subject (Figure 3.12). There are close-up subjects that are quite symmetrical and look very interesting when they are centered in the image. A sunflower might be a good example of this. When you focus in on that sunflower and you put it in the center of your frame, you will create a very dynamic composition that highlights and shows off the qualities of the sunflower. But there are not a lot of subjects that have that kind of built-in centering.

Figure 3.12 For some subjects, a centered composition might be the perfect way to create a dramatic photo.

Balance and Unity

Balance and unity are very visual concepts. Balance is how one side of the image looks compared to the other, as well as how the subject relates to the space around it, especially from side to side. When one side of the image dominates the photo, the image is said to be out of balance, and it doesn't look right to a viewer. The whole image is important, not just the subject.

You could get balance if you centered your image and everything on both sides was equal. On some close-up subjects, that could be very interesting, but for most, that is going to create a boring image. Usually you will be working for balance with images that are not centered, such as using the rule of thirds. The rule of thirds gives a type of visual balance which is why it is always worth considering.

Unity is related to balance because it also relates to the whole image. As you compose your picture around your subject, it is important that everything in your composition belongs there, that it has unity. If there are some stray twigs or a random sharp object along the edge of the picture, the picture will look unbalanced because the image doesn't have a feeling of wholeness. Balance and unity both require a feeling of wholeness, that everything belongs in the photograph. So it is important to root out distractions, especially around the edges, that take away from the balance of the image (Figure 3.13).

Figure 3.13 Watch your edges for distractions. They can upset the balance and unity of a composition.

Balance can also come from the way that you use multiple subjects. For example, you could have three flowers that spread out through the composition. If those flowers were all crammed at one side of the middle, the picture would look unbalanced. But if those flowers are positioned around the middle, you will have a better balance.

Space in the composition is also very important to balance and unity. When your subject is sharp and the background is out of focus, you'll often have a feeling of space around your subject. The balance comes because of the way you use this space. You can balance something on one side of the frame, like your subject, with space on the other. But that space has to be space that is clearly seen as space by the viewer. If space on one side of the image has a lot of detail showing up from the background, for example, there will not be a balance or unity because of all that detail.

Vertical and Horizontal Compositions

Cameras are designed to be used most easily in a horizontal position. This is especially true for close-up work because it can be difficult to hold the camera vertically when you are getting close to the subject, plus it is more awkward to position the camera vertically on a tripod.

Yet the world is not always filled with horizontal subjects. Often you will find that a composition will not have the right balance if you try to put a more vertical macro subject into a horizontal frame.

To get a more interesting variety of close-up compositions, try shooting more verticals (Figure 3.14). This will often mean that you will have to force yourself to shoot vertically. Yet once you get in the practice of shooting both horizontal and vertical pictures, you will see a greater variety of possibilities for close-up subjects.

Showing the Whole Subject or Focusing in on Details

An interesting thing happens when you start looking at how a composition shows off your subject. If your composition shows the entire subject, including all of its outside edges, your viewer will see that entire subject. The result is that the shape and overall form of the subject becomes most important for the composition.

However, if you go in closer, pushing the macro capabilities of your lens so that you get in so tight that you no longer show the outside edges of your subject,

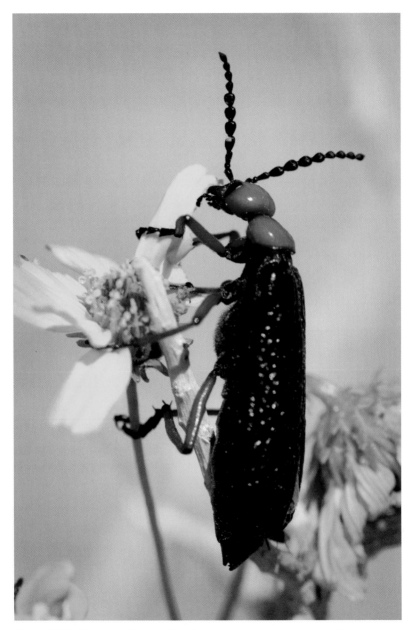

Figure 3.14 Verticals offer a quick-and-easy way to vary your compositions.

Figure 3.15 A shot that eliminates the outer edges of your subject will emphasize its details.

you now have a very different look. You are not allowing your viewer to see the outside edges so the viewer cannot look at the overall form or shape of your subject. The viewer is forced to look at the details, as shown in Figure 3.15.

Sometimes it is these details that are the most interesting part of your subject. You have to decide if they are important enough to get in tight to emphasize them. Or do you show the outer edges and even some of the environment of your subject? What is your picture truly about? No matter how cool the detail is of a macro subject, if you show a strong outline of the entire subject, that's what your viewers will look at. If you want people to really look at the details of the subject, then you need to get in close and eliminate as much as possible those outside edges of your subject. It is all a matter of emphasis.

Abstract Designs and Tight Close-Ups

When you get in tight to a subject, sometimes the close-up composition changes to an abstract design. Abstract designs can be fascinating photographs and they are very easy to do with close-up and macro photography. You do need to be in tight enough that you eliminate any details that take away from

the abstract design. Here are some other things to think about to create your own close-up abstracts:

- **Use a telephoto lens.** A telephoto lens will flatten out the depth of the subject and help emphasize the shapes and planes.

- **Isolate patterns in your composition.** As you move in close to your subject, start looking for patterns to appear. Tighten up your composition to emphasize those patterns so that there is nothing else but pattern in your frame.

- **Ignore the subject.** An abstract design works on its own apart from what the subject might be. Look for the design, not simply the subject.

- **Use strong lines and shapes.** Lines and shapes are key to an abstract design. Look for strong lines and strong shapes that clearly show up in your composition.

- **Work with flatter subjects.** Since depth-of-field is so narrow up close, a flatter subject will hold sharpness better, so show off its lines and shapes.

- **Use a small f/stop.** Graphic designs tend to work best when they are sharp. By shooting with a small f/stop, you gain the most sharpness in depth possible.

Figure 3.16
Abstract designs become your composition when you isolate patterns in your composition.

Chapter 4

Making the Most of Lighting

You have a distinct advantage with close-up and macro photography for how light is employed. With many subjects, you have limited ability to change your position relative to the light. For landscapes or cityscapes, the only thing you can do is come back at a different time. But for close-up work, this changes completely. It is very easy to move around your subject to change how the light is affecting your subject. Sometimes moving only a few inches can totally alter the light on your subject (Figure 4.1).

Figure 4.1 When you are this close to a subject, even a slight change in your angle will make a big change in the light.

In addition, it is very easy to control the light on your close subject. You can usually move the subject slightly to get it in or out of a certain light. You can block light that is too harsh, defuse it, or even reflect the light into the shadows.

Even though light is so easily affected with close-up photography, many photographers miss the opportunity to capture great light on their subject. People don't normally look at close-up and macro subjects as close as you get when you are photographing them. These subjects look dramatic and bold in the viewfinder on the LCD, and that dramatic look can be distracting. Because this gives the subject such a unique look, photographers often find it easy to miss the light. In this chapter, you'll find tips on how to see and use the light for this type of photography.

Seeing the Light

To get started getting better light on your close-ups, you truly do need to *see* the light. You will find some good ideas in Chapter 3 about focusing on the photograph, not just the subject, that will get you started. People focus on subjects, but the camera literally sees the light. Not only does the camera have to see the light to capture an image, it has a tendency to over emphasize the difference between bright areas and dark areas from that light.

If you only see the subject, you will often miss the light. This is a big reason why many people are disappointed in their close-up photography. The subject looked so great! That may be true, but the camera saw and emphasized the light, including distracting shadows on the subject as well as bright spots in the background. The light did not show off the subject.

Looking for light and not just subjects is a very different way of seeing for most photographers. You may be used to looking for subjects and hoping the light will be okay. Just changing this perspective, that is, looking for light to photograph, not just subjects, usually gives a quick boost to your ratio of better photos.

Here are some things you can do to get started seeing the light on your close-up subject:

- **Use your LCD.** The LCD shows you a miniature image that tends to emphasize the light. If the light on your subject looks good on the LCD, then it is going to look good as a larger picture as well. If the light is making your subject hard to see on your LCD, then the bigger picture is not going to be improved.

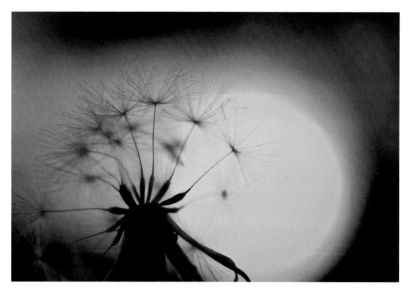

Figure 4.2 Photograph the light itself along with your subject for a great exercise in learning about light and macro shooting.

- **Photograph the light.** An excellent exercise for any photographer is to spend some time simply photographing light. Go out with your close-up gear and look for light to photograph, not just subjects. Look for the light on your subject and photograph this effect, not just the subject. This will quickly teach you a lot about seeing light. See Figure 4.2.
- **Look for the shadows.** Shadows can be as important as the light itself. Look for the shadows on your subject and what they are doing to it. Shadows can help your subject stand out from the background, but they can also obscure and distract.
- **Experiment.** It is so easy to experiment with a close-up subject because you can move around it. Try shooting the same subject from several angles just to see the differences in the light.

Dramatic Light

One way to work with light is to start looking for particular types of light, such as dramatic light. Think of the theater and you immediately are thinking about dramatic light—light that emphasizes one part of the set over another, dramatic differences in light from the actors to the background, spot lights, and so on. Dramatic light is usually light that is bright and contrasty. There is

a big difference between the brightest areas and the darkest areas of the scene that are hit with dramatic light. Whenever the sun is out, you have potential for this type of light.

Spot Light

Spot light is a good start because it is such a recognizable light. It happens when the light hits a spot in the scene, such as your subject, and nothing else in the scene, as shown in Figure 4.3. This is a great way to emphasize a close-up subject. This is a light to recognize and look for as you examine your subject and its surroundings. This most commonly occurs on bright, sunny days with lots of shadows. Look for sunlit spots of light surrounded by shadows.

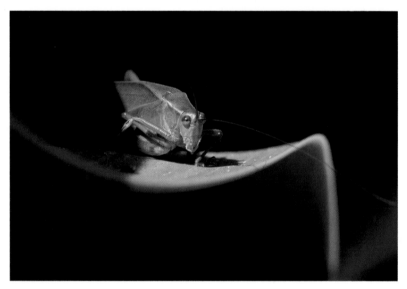

Figure 4.3 A spot light is a dramatic spot of light on your subject, setting it off from the rest of the scene.

But again, pay attention to the light, not just the subject. When photographers start using spot light, they often only see what is going on with that light on the subject. If there are spots of light all over the photo, especially on the background, that will likely be confusing to a viewer. A spot light is exactly like the spot light in a theater. It lights up the actor, or in this case your subject, so that it stands out from the rest of the scene.

Consider these things when you are looking for and working with spot light on a close subject:

■ **Look for a spot of light just on your subject.** Sometimes you have to move around slightly to see the spot light on a subject. And remember that with small subjects used for close-ups, you can often move them into a spot of light. If you have a flower, you can bend the flower into that light.

■ **Look for a dark background behind your subject.** When your subject is in the light and the background is not, you can get a very dramatic look because of the contrast between subject and background.

■ **Watch your exposure.** Be aware that your camera may try to give too much exposure to a spot lit subject. It sees all of the dark areas behind your bright subject and then overcompensates by overexposing the subject.

■ **Watch out for too harsh of a light.** Spot light can provide a very harsh light that isn't appropriate for every subject. If it makes your subject look bad, then don't use it even if it is dramatic.

Backlight

Backlight, or light from behind the subject, is almost always dramatic, and it can be a challenge to deal with. If anything, a camera will make light more dramatic, even harsh, so you do need to be careful when using this light. Because of that, many photographers avoid it. That can be very limiting to your photography.

Backlight offers so many good opportunities for close-up and macro work. It can make a translucent subject glow. It can create a highlight around the edges that really sets your subject apart from the background (Figure 4.4). It can create a dramatic silhouette or show off textures and hairs on your subject. You can create very dramatic and effective photos with backlight.

Here's how to work with it for your close-up photography:

■ **Make sure your light is behind the subject.** Backlight is light that is coming from behind your subject, so to get maximum effect, you need to be sure that it really is coming from behind your subject, toward your lens.

■ **Use a lens shade.** A lens shade or lens hood is very important whenever you are shooting backlight. Backlight means that light is going to be going into your lens directly from the sun or other light source. This light bounces around inside your lens and creates flare. A lens shade will help minimize this.

Figure 4.4 Backlight makes colors glow and creates a rim of light around the subject to set it off from the background.

- **Look for translucent light.** A backlight will make a translucent object look its best. It helps to define the tonalities of such a subject and can make colors really glow in a picture.

- **Use a separation light.** Backlight is known for its ability to separate parts of your picture and make your composition more clear. Backlighting helps separate your subject from other parts of the scene by creating brighter areas along the top and back edges that contrast with other parts of the picture.

- **Make use of an out-of-focus sun.** When you are really close to a subject and the sun is behind it, the sun will be out of focus, but it will also appear to be very large. You don't need a telephoto lens to make the sun appear larger—the sun appears larger the more out of focus it is.

- **Find out-of-focus highlights.** Bright highlight spots in your background can create interesting shapes. They will take on the shape of the inside of your lens aperture. If you shoot wide open, the lens will be a perfect circle and so will the out-of-focus shapes.

- **Try an in-focus sunburst effect.** Get close to your subject with a wide-angle lens, stop the lens down to a small f/stop, and then make sure the sun is in your composition. The sun will appear as a sunburst or starburst

pattern. This will not show up against a very bright background, but when dark areas are around this pattern, it will show up very well.

■ **Be careful of exposure.** Avoid too much exposure that washes out your dramatically lit subject. And avoid too little exposure that makes the image look murky with dingy bright tones.

Light and Shadow

Shadows are often important to a photograph, and sometimes they can be a key element of the composition. You can even create close-ups that are purely about light and shadow where we only see the subject through its shadow, as shown in Figure 4.5. It can be a lot of fun to search out shadows, finding images that go beyond simply capturing the subject. As you look for shadows, you are also looking for light, so this will also help in your quest for better light on your subject.

The key to a shadow is obviously the light. With a strong, sharp light, such as that from a direct sun, there will often be interesting shadows that could be their own photograph. However, it is worth remembering that such light can be distracting when it creates all sorts of competing bright spots, shadows, and

Figure 4.5 This close-up of a grasshopper is revealed through its shadow.

shapes in the background. But when shadows strongly emphasize your subject or composition, they can become magical.

Here are some ways to use shadows with your close-up photography:

■ **Look for shadows.** That might seem obvious, but most photographers doing close-up work do not look for shadows. They look at the subject. You start getting better images with shadows simply by recognizing that they are there.

■ **Show off parts of your subject.** Shadows don't have to be so dramatic that they are the entire photograph in order to work well for your close-up photo.

■ **Be sure the shadows don't fight with your subject.** One challenge for close-ups and shadows is that they can be so strong that they fight with your subject. Look beyond your subject, especially at the background from edge to edge, corner to corner.

Dimensional Light

Photography is a flat, two-dimensional medium. While many companies have tried to create 3D effects with photos, they never look quite right, in part, because they still have to work with a two-dimensional, flat image. Maybe that will change in the future, but this limitation is also an invitation to working with light.

Many macro subjects have very strong dimensional looks in real life. They are far from flat, yet they must be displayed as a flat image. Light can make the subject gain dimension and form, giving it life in the photograph. A dramatic light that brings out the form of your subject can be a very effective close-up light. Here are some ways to work with it:

■ **Shadows give dimension.** You have to see shadows on a subject in order to see that it has depth and structure.

■ **Light must cross the subject.** For light to reveal dimensions, it needs to cross an object in such a way that it makes some areas bright and others shadowed.

■ **Use sidelight for form and dimension.** Sidelight will usually give the strongest dimensional light (Figure 4.6) as long as it emphasizes form more than texture.

■ **Try backlight for form and dimension.** Backlight can also give dimension and form to your subject, but it is not the same as sidelight. If the light is low, it will give two-dimensional silhouettes, but as the light goes higher, it creates form.

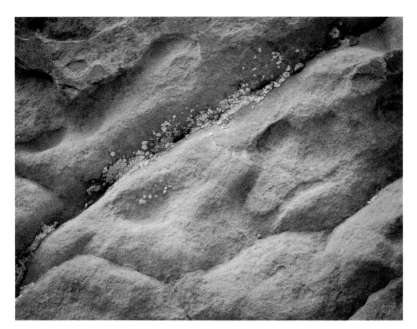

Figure 4.6 Sidelight creates form and texture on this detail of rocks, but the dimensional forms are strongest.

Textural Light

The right light reveals texture. Texture is an interesting part of the macro world. It can be an important part of so many close subjects. One thing that can often set one subject apart in a photo is texture. Texture and the contrast among the textures can give an image its strength.

Texture comes from light and shadow that defines the little bumps and surface changes. If you don't have that light and shadow, the texture will be deemphasized or even lost. Some subjects are all about texture. You can even see different types of certain subjects simply by looking at the textures.

Here are some things to think about to help you work with texture:

- **Look for low light.** Low light that skims across a surface really works well to show off texture by emphasizing the differences over a surface by giving them distinctive light and shadow.
- **Sidelight is good for texture.** Light coming directly from the side of your subject will provide strong shadows where they are needed to show off texture (Figure 4.7).

Figure 4.7 A low sidelight brings out the texture in this flower.

- **Backlight might be good for texture.** A high backlight that skims across the surface of the subject will bring out texture. If backlight is too low, your subject will only be in shadow and texture will not show up.
- **Strong direct light from the sun does really well with textures.** Light from clouds or sky does not.
- **Front light is bad for texture.** Front light, light from behind your camera that is directed at the subject, fills in shadows, eliminating texture.
- **Harsh sidelight can be a problem.** When light creates large shadows and harsh bright areas that compete with the detail of the textured areas, texture will be obscured.

Solid Light

Solid light is simply a light that makes your subject look very solid. For some close-up subjects, that is very important. For others, you want a different sort of light that will show off things like texture or translucency. A light that makes a subject very solid looking tends to obscure texture and translucence, so keep that in mind.

Sometimes the best light for close-ups is light that makes subjects look solid with opaque colors. Here are some tips for getting a solid-looking subject from the light:

- **Use front light.** Light hitting the front of your subject as it faces you tends to make things look very solid. Pure front light is almost impossible to use with close-ups because as you try to photograph with that light, your shadow falls on the subject.

- **Front light that is low and a bit to the side works very well.** Light coming in from the front and a little to the side can nicely light up your subject, plus it makes the colors strong and solid looking (Figure 4.8). It also makes it easier for you to use the light because you are less likely to get your shadow on the subject.

- **Use a telephoto.** When you shoot a close-up with a telephoto lens, you can back up to allow the front light in without your shadow encroaching the subject.

Figure 4.8 The low front light on this flower emphasizes its solid shape and color pattern.

- **Front light can be a dull light.** Front light is tricky because it can fill in all the shadows, making the subject look flat. That is another reason to use it a little to the side.

- **Move your camera position for the background.** By changing your camera position just a little, you can often find a part of the background to help give the photo a little contrast and strength for the front light.

Soft Light

Bright sun is not the only light to use for close-ups. The softer light created by cloudy days can often bring a nice look to a close subject. Soft light is any light that is gentle on the subject and does not create sharp-edged, strong shadows. It comes from a cloudy day, open shade, or any time you block the sun off of your subject when you are outside. You can also create it indoors with lights that bounce off of large reflectors.

Soft light can be an enveloping light that creates an even tone and color across the photo. Soft light is great for showing off subtle colors. Bright sun and dramatic light can so strongly emphasize light and shadow that gentle colors are overwhelmed. You will often find lovely soft colors revealed in soft light that would be lost in bright sun (Figure 4.9).

Figure 4.9 A soft light reveals the colors and tonalities of this detail of a forest floor.

Backlight is dramatic when it comes from the sun, but it can also be quite beautiful as a softer light from clouds or sky. Some of the same ideas you learned for dramatic backlighting have application to working with soft backlight. There is no question that soft light is a simpler light than dramatic sunlight because it does not radically change as you move around your macro subject.

Here's how to work with soft light:

- **Look for shadows.** Some sort of soft shadow can be important. Gentle shadows below the subject can give it form. Shadows come from some sort of dimension to the light, even if soft, especially when it comes from a limited area, such as a smallish opening in the trees above you.

- **Be wary of dull light.** A danger in this light is that it can make for a flat and dull photo if the subject itself does not have some good tonalities or colors in it. It can also be unattractive if the light is very heavy and dull, such as that from heavy, dark clouds.

- **Keep blank skies out of the photo.** Blank skies can be deadly for any composition, but they can be too common with soft light conditions when you are shooting at a low angle. Even out-of-focus skies in these conditions will create blank white areas that are very distracting for the photo.

- **Bring out contrast and color in the computer.** You will often need a bit of processing in Lightroom, Photoshop, or Photoshop Elements to bring out the color and detail in a soft light photo because cameras do not always capture this light in an optimum way.

Controlling Light on the Macro Subject

Existing or natural light is not always optimum for your subject. It can be too harsh. It can be too dull. It can create confusing shadows and highlights or create a flat light that makes the subject hard to see. And there can just be too little of the light to allow you to get a good picture.

You can conquer these obstacles by the use of some simple tools that allow you to control the light. These range from reflectors and diffusers to the flash on your camera, as well as accessory flash that you attach to your camera.

Using Reflectors

Reflectors are anything that reflect the light onto your subject. They're frequently used to reflect light into shadows to better balance the brightness between shadow and highlight. (See Figures 4.10–4.11.) They are great for close-up and macro work because you don't need a large reflector for such subjects and they are easily positioned around the subject.

Figures 4.10–4.11 A reflector can brighten shadows in strong sunlight.

Photographic reflectors come in two surfaces: shiny and matte white. Shiny reflectors bounce the light off them onto the subject. They are highly reflective and can be silver to reflect the light directly or gold to warm the light up slightly. They can even be used to throw light into a shadow that has no direct sunlight.

Matte white reflectors are less reflective but they also throw a gentler light on the subject. They are frequently used to fill in the shadows of a subject in bright light. They can be particularly effective when you are shooting backlight.

A reflector can also be used to block the light. Sometimes the light on your subject is just too harsh and too filled with shadows to make the subject look good. By holding a reflector over your subject, you block the direct light and allow a gentler, softer light to illuminate your subject.

You can use all sorts of things for reflectors. Here are some ideas:

- **Buy white foam board.** Go to an art or office supply store and buy a piece of foam board. You can cut this into a smaller size that will fit your camera bag. Foam board is lightweight and inexpensive but makes a very good matte white reflector (Figure 4.12).

- **Try a small mirror.** Go to a discount store or drugstore and look in the cosmetics section for a small, portable mirror. These mirrors are great for directing sunlight onto a subject that is in the shade. They can also help light up the underside of a subject that has all of the light coming from above.

- **Get a car sunshade.** You can find highly reflective sunshades at any store that sells automobile accessories. These sunshades are designed to go on your dash to help keep the car cooler. They also work great as reflectors for photography.

- **Check out a folding photo reflector.** Camera stores sell small, folding reflectors that easily tuck into your camera bag. They will come in different surfaces from white to silver to gold.

Figure 4.12
A small piece of foam board makes a good, portable reflector.

Using Diffusers

A diffuser is anything that is translucent and neutral in color that can be placed between the light and your subject (Figure 4.13). It blocks the direct light and spreads it out to make it softer. It takes a direct, harsh light and diffuses it so that the light is gentler and more usable (Figure 4.14).

The diffuser becomes, in a sense, the light source for your subject. Because of that, you can move the diffuser around your subject to change the light. A

Figure 4.13
A diffuser fits between the light and your subject to diffuse the light.

Figure 4.14 The light from a diffuser is gentler than direct light.

diffuser that is mainly to the side of the subject will create a very different light than if it is mostly above. Watch how the relationship of bright areas to shadows change as you move the diffuser around the subject. In addition, how close you have the diffuser to the subject will affect the look of the light.

A diffuser can also be helpful when you have problems with wind moving your subject around. The diffuser can block the wind without affecting the light as much as a reflector would.

One thing to be careful of when using a diffuser is the relationship of your subject to the background. When you use a diffuser, the brightness of the light is dropped compared to the direct light. If that bright light is still on your background, that can mean your background will get very bright compared to the subject that is under your diffuser.

You can use all sorts of things for diffusers. Here are some ideas:

- **Buy a white plastic cutting board.** Go to a cooking supply store and look for a flexible, white cutting "board" or sheet. You can cut this into a smaller size that will fit your camera bag.

- **Find a white, translucent shower curtain.** Most places that sell shower curtains will carry translucent white plastic curtains. This material makes an excellent diffuser, although you will need to find some way of creating

a frame for it. You can find some simple, easy frames that are designed to hold fabric at an arts and crafts store.

■ **Check out a folding photo diffuser.** Camera stores sell small, folding diffusers that tuck into your camera bag.

■ **Look into a photo diffusion box.** Another product on the market for macro photographers is a white, translucent box. Many of these are highly portable and can be taken outside as well as used inside for tabletop photography. The box surrounds the subject with white translucent material to give an even, soft white light on the subject.

Working with Flash

Flash is intimidating to a lot of photographers. Entire books have been written about flash. Yet, flash can be a very helpful tool for close-up and macro photography. It does not have to be difficult in order to be effective. There are some things you can do simply and easily when using flash up close.

Understanding what flash offers for the macro shot can get you started:

■ **Controlled light.** No matter what kind of day it is or where you are, inside or outside, flash gives you a controlled and consistent light.

■ **Sharper photos.** Because you are very close to your subject with your flash, there is a lot of light reaching your subject, which affects exposure. Because of this, you can use a small f/stop for maximum depth-of-field (Figure 4.15). The very short duration of flash also eliminates camera movement during exposure.

■ **Fast "shutter" speed.** Flash has an extremely short duration. When you use automatic flash up close, it gets even shorter. You may be shooting with a flash duration of 1/10,000 second, which will stop most action.

■ **Better light on cloudy days.** Cloudy days can be a problem for close-up work because the light often has no dimension to it. In addition, lower light levels mean fewer options for f/stops and shutter speed. Flash offers dimension (Figure 4.16) and more f/stop control.

■ **Control over background brightness.** Sometimes you will have a background that is too bright compared to your subject. With flash, you can add light to your subject to increase its brightness relative to the background. This allows an exposure that will make your background darker because the background does not get the flash.

Figure 4.15 This small flower is revealed in all of its detail through the use of flash.

Figure 4.16 Flash gives this close-up detail of petrified wood more contrast and form on a cloudy day.

Using Your Camera's Flash

If your camera has a built-in flash, you can use it for close-up work. You gain many of the advantages that were just discussed about the use of flash, although because the flash is locked to a single position on your camera, you can't move it around to add dimension to your subject.

Camera manufacturers have different approaches as to how they match the light from your flash with existing light on your subject so you will have to check your manual to see what the best way to handle your flash is. However, it is relatively simple to choose manual exposure on any camera while using autoexposure with the flash. With the camera set to manual, set your f/stop to f/16 and your shutter speed to the camera's flash sync speed (usually 1/125–1/250 second).

You can usually use your flash on automatic. You may have to use your flash exposure compensation to adjust the light if the subject is much brighter than the background. An overexposed subject is a different story. Because you are so close to your subject, some cameras cannot control the flash well enough to limit how much light goes on the subject. The subject gets overexposed. All you have to do is cut down the amount of light heading to your subject from the flash by blocking part of your flash with a finger or holding or taping a small piece of diffusion material over the flash (Figure 4.17).

Another problem comes when the flash is blocked by the lens. When you are shooting macro images with the flash on your camera, your lens may be big enough to block some of the light from the flash, creating a shadow on your subject. Here's how to fix that:

- **Take off the lens shade.** Lens shades are good to block extraneous light and to protect the front of your lens as you get close, but if your built-in flash is blocked, take the lens shade off.

- **Shoot with a telephoto focal length.** A telephoto allows you to back up from your subject, giving space that often allows the flash unobstructed access to the subject.

- **Move the position of the light source.** Since you can't physically move the flash built into your camera, you have to do something else. Take a Styrofoam cup and place it over your flash, pointing the cup forward and up. The cup now becomes the light source (and gives a very pleasant light for close-ups, too, as seen in Figure 4.18).

- **Try a photo flash diffuser.** A number of companies make small diffusers that fit over your flash and sometimes that will be enough of a change to eliminate the shadow problem.

Figure 4.17 A piece of white translucent material was held over the camera's built-in flash for this image of cherry blossoms.

Figure 4.18 A Styrofoam cup over a built-in flash provided the light for this little spider.

Working with an Accessory Flash

By adding an accessory flash to your close-up gear, you gain additional control over the use of flash. Accessory flash offers more power, though that is not usually needed when using it pointed directly at the subject. Where that extra power helps is when you use flash modifiers such as diffusers and reflectors to change the light coming from the flash to make it less harsh and direct.

Accessory flash units usually stand much higher above your camera compared to a built-in flash and that can help eliminate the problem of light being blocked by the lens. You can also tilt most of these flash units to aim them at your subject or to raise them up so less light hits the subject directly. They can be tilted to reflect against a white reflector, too, in order to modify the quality and direction of the light.

A big help for close-up work comes from using an off-camera accessory flash. Why would you want to shoot your macro shots with a flash off of the camera?

- **Move the flash for better light.** It often helps, for example, to hold the flash to one side or the other, and slightly above, the subject. (See Figure 4.19.)

Figure 4.19
A flash held to the right and above the subject gives this novelty flower pot dimension and life.

- **Gain the benefits of dimensional light.** With the flash off-camera, you will be working with a light that has strong highlight and shadow possibilities to add dimension to your subject.

- **Utilize a textural light.** By putting your flash strongly to one side or the other of your subject, you can really accentuate texture.

- **Change the light on the background.** By moving your flash around and tilting it slightly, you ensure that the light is more on your subject than on the background. That can help your subject stand out better.

A great thing about shooting digital with off-camera flash is that you can immediately see what your results are in your LCD. If you don't like the position of the flash or it is lighting the wrong parts of the subject or background, simply change the position of the flash and shoot again (Figure 4.20).

Figure 4.20
Holding your flash off-camera lets you position the light where you want it to go.

There are two ways of getting your flash off-camera: wired or wireless. You can get a dedicated flash cord for your specific camera and flash that will allow you to hold the flash up to about three feet away from the camera. A dedicated cord is very simple and easy to use—you don't have to make any special settings other than plugging it in, and the flash is always connected to the camera in all conditions.

Wireless flash is a relatively recent development among camera manufacturers. Many cameras and flash units communicate wirelessly to flash that are off the camera. The advantage of these units is that you do not have a cord connecting you to the camera which allows you to put the flash in more places. The disadvantage is that setting up a wireless flash does require a bit of work with many cameras and there are certain conditions where it won't work consistently when you are outdoors.

Using Twin Flash and Ring Flash

Twin flash and ring flash are two unique types of flash designed for close-up work. Some photographers love them and use them all the time for this work, but other photographers find that an off-camera flash is perfectly fine. There is no right or wrong for how a photographer uses flash up close.

A twin flash system uses two small flash units mounted to a special ring that surrounds your lens (Figure 4.21). There are other twin flash systems that mount the flash to flexible arms at the sides of the camera as well. The two flash units are easily positioned to allow for a variety of light on your subject. The common way of using these flash units is to simply have them slightly above the lens and on both sides of the lens.

Figure 4.21
Twin flash systems use two flash units mounted on a ring that goes around your lens.

The default setting for most of these flash units is to have both of the units at the same power. That causes some problems because although it will give mostly even illumination for the subject, it also gives double shadows that are very unnatural. A better way to use the twin flash is to set one of the units as the main light and use the other one as a fill light (Figure 4.22). You dial the ratios so that the brighter light is at least four times as bright as the fill light.

A ring flash unit surrounds the lens with the flash light (Figure 4.23). This gives an essentially shadowless light because the light is coming from the axis of the lens. Shadows fall behind the subject so they are not seen. For some subjects, this can open up detail and pattern and show off minor color differences in the subject. This is one reason why ring flash is used in medical and dental applications because that sort of detail can be very important when looking at a medical or dental problem.

Ring flash are less useful for more usual close-up and macro subjects. Without any shadows, a lot of these subjects lose their form and definition.

Figure 4.22 For this image, the flash on the left gives a stronger light than the second flash on the left.

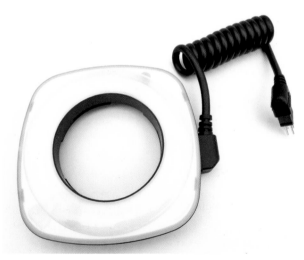

Figure 4.23
A ring flash is designed to mount on your lens so the light surrounds it.

Chapter 5

Changing Focal Lengths

What gear gets you close? A surprise for many photographers is that it's not just macro lenses! You don't have to wait until you can afford a macro lens in order to get outstanding macro photos. In fact, doing all of your macro photography with a macro lens can limit you from getting the best shots up close. Using different gear often means opportunities to get unique and special images (Figure 5.1).

The point is also about working with what you have. Your chance to shoot up close is more important than some arbitrary lens that the folks at the camera club say you have to have. You don't have to let a few dollars get in the way of good photos. Exploring the possibilities in this chapter will encourage you to try all sorts of things with close-ups.

How to Use Different Lenses

There are many options available to allow you to use almost any lens up close. In fact, some lenses allow you to focus up close without any accessories at all. Some compact digital cameras have a specific close-up setting that allows you to get within inches of the front of the lens. Discussed next are four different ways that will get you up close, and some of them rival macro lenses for image quality.

Close-Up Lens Attachments

These are the least expensive close-up accessories you can buy. Close-up attachments are simple magnifying lenses that screw onto the front of your camera's lens (Figure 5.2). You can buy them in sets of three that have increasing power. These are the least sharp option of any of the close-up accessories but give reasonable results when your main lens is stopped down to a medium f/stop such as f/11. In fact, they can produce a rather soft and dreamy look that some people think is a cool effect. However, their biggest advantage is that they are

Figure 5.1 A telephoto lens used up close gave this unique perspective and background for these bromeliad flowers.

relatively inexpensive. Here are some things to look for when buying and using them:

- **Filter plus rating.** Check the filter's plus rating, such as +2 or +4. The stronger the plus rating of any close-up filter, the closer you will be able to focus with your lens.

- **Attaching to your lens.** Use close-up filters on any lens that offers the ability to add screw-on filters.

- **Fit your physically widest diameter lens.** Buy close-up filters big enough to fit the filter ring of your widest lens.

- **Buy adapter rings.** Adapter rings allow you to attach the filters to other lenses with different filter sizes. You can't, however, put a small close-up filter in front of a lens with a wide diameter because this will not allow all the lenses to work together properly.

- **Zooms act strangely.** Close-up filters give different results depending on the focal length that you use them with. In fact, a zoom lens no longer acts like the zoom lens you used to know. As soon as you start to zoom, you will find that the subject gets out of focus.

- **No distant focus.** You cannot focus at a distance when a close-up filter is on your lens.

- **No exposure change.** Using a close-up filter has no effect on exposure.

- **Protect your filters.** Close-up filters are very susceptible to scratching because they are constantly being handled and taken on and off lenses.

Figure 5.2
Close-up
attachment.

Extension Tubes

Extension tubes are inexpensive, versatile, high-quality close-up accessories. If you can't afford a macro lens, be sure to look into extension tubes (Figure 5.3). Even if you have a macro lens, extension tubes will increase your capabilities for close-up photography. They are very affordable and can be used with all but the widest-angle lenses on a dSLR. In fact, they are ideal for telephoto lenses. They are literally tubes without any glass in them. They fit between your camera and lens and enable that lens to focus much closer. Think about these things when buying and using these accessories:

- **Buy them in sets.** You can find extension tubes sold in a set of three tubes of varying lengths. These sets tend to be much less expensive than buying extension tubes individually.

- **Almost any lens can be used.** Extension tubes can make almost any lens focus as close as a macro lens (wide-angles can be the exception) and do it relatively inexpensively.

Figure 5.3 Extension tubes fit between your camera and lens to allow a lens to focus closer.

- **Size of tube affects close focusing.** How close an extension will let you focus depends on the amount of extension in the extension tube.

- **Focal length of the lens affects close focusing.** The more telephoto your lens is, the more extension you need in order to use it up close. This is why extension tubes come in sets.

- **Macro zoom.** Extension tubes will make a zoom lens act like a macro zoom, too, although the zoom will change focus as you zoom.

- **Very durable and portable gear.** Since extension tubes have no optics in them, they are very rugged. A few extension tubes add little weight and take little space from a camera bag.

- **Results will vary.** Since the extension tube has no optics of its own, image quality will vary depending on the lens used with it.

- **Not all lenses work well with extension tubes.** Some quality lenses simply do not like to be used up close and will not give great results. On the other hand, sometimes you will be surprised at how well an average lens might do up close. The only way to know is to try.

- **Exposure changes.** Extension tubes move the lens away from the camera body and so reduce the light to the sensor. The result is that your exposure will change, requiring a slower shutter speed or a wider aperture.

Tele-Extenders

Tele-extenders or tele-converters are similar to extension tubes in that they fit in between your camera body and lens (Figure 5.4). However, tele-extenders include optical elements inside them. Their optics magnify the view coming through your lens and make your lens act like a stronger telephoto lens.

Technically, tele-extenders do not allow your lens to focus closer. However, since they are magnifying what is coming through the lens, they will give a closer view of your subject. With some lenses, this can be a significant effect and allow you to get quite interesting close-ups of your subject even though you have not changed your distance to that subject. Think about these things when buying and using a tele-converter for close work:

- **Tele-extenders work best with telephotos.** Tele-converters are not recommended for certain lenses that are not telephotos.

- **The close focusing of the original lens does not change.** Remember that a tele-converter is not letting your lens focus any closer; it is just magnifying what it sees.

- **Macro zoom.** Tele-extenders will make a zoom lens act like a macro zoom, too, although the zoom may change focus as you zoom. Not all zooms work well with tele-extenders, however.

Figure 5.4

Tele-extenders fit
between your
camera and lens
to magnify what
the camera lens
sees.

- **Results will vary.** Since the tele-extender has its own optics, image quality will vary depending on how well the two lenses work together.

- **Mid-range f/stops work best.** Since image quality is affected by the interaction of tele-converter and camera lens, use the sharpest f/stops for your lens, which are usually f/8 and f/11.

- **Exposure changes.** Tele-extenders reduce the light to your sensor by 1–2 f/stops.

- **Not all lenses work well with tele-extenders.** Some lenses, especially certain fast zooms (zooms with a wide aperture), just do not mesh well with tele-converters and results will be poor. Also, some lenses with a back optical element extending to the back of the mount will be damaged if you try to use them with a tele-converter.

Achromatic Close-Up Lenses

Achromatic close-up lenses are definitely a more sophisticated option and sharper than close-up filters. These lens attachments are highly corrected lenses (using two optical elements) that you screw into the front of your lens and fit any camera lens with the same or smaller filter size (Figure 5.5). You can get remarkably sharp macro shots with them.

Only a few manufacturers make these lenses, but since they screw into the front of your lens, they can be used with any brand. They will run about $80–$200 depending on the size, but the high image quality makes them well worth the cost.

Figure 5.5 An achromatic close-up lens attaches to the front of your lens.

How you buy and use them is very similar to close-up filters:

- **Filter plus rating.** The stronger the plus rating of an achromatic close-up lens, the closer you will be able to focus with the camera lens.

- **Fit your physically widest diameter lens.** Buy achromatic close-up lenses big enough to fit the filter ring of your widest lens.

- **Buy adapter rings.** Adapter rings allow you to attach these lenses to different camera lenses with varied filter ring sizes.

- **Zooms act strangely.** Close-up filters produce different results depending on the focal length that you use them with.

- **Wide-angle close-ups.** Achromatic close-up lenses can help most wide-angle lenses focus closer, though extreme wide-angles may get distortion along the edges.

- **Large diameter close-up lens for wide-angle.** If your achromatic close-up lens is too small, some vignetting or darkening of corners of your image will occur.

■ **No distant focus.** You cannot focus at a distance when a close-up filter is on your lens.

■ **No exposure change.** Using an achromatic close-up lens has no effect on exposure.

■ **Results will vary.** It is hard to predict how well an achromatic close-up lens will do with any given camera lens, because you are adding a whole new set of optics that were not originally part of the camera lens.

■ **Protect your filters.** Achromatic close-up lenses are very susceptible to scratching because they are constantly being handled and taken on and off lenses.

The Macro Lens

Macro lenses are specifically designed for close-ups and have very high image quality (Figure 5.6). They are a very good way to get close, but as you've seen, there are other good options, too.

Figure 5.6 A macro lens lets you focus from infinity to macro without accessories.

Some things to think about regarding macro lenses include:

- **Infinity to macro.** With a macro lens you can focus from distant to close without adding anything to the lens or camera. Your shooting is therefore more fluid.

- **Wide apertures are sharp.** When you get to really close distances and select wide apertures, macro lenses will beat nearly any other lens in terms of quality.

- **Flat-field sharpness.** All lenses have a slight curvature to their plane of focus. For many subjects, this doesn't matter. But if you're photographing flat objects, that curved field can result in centers being differently focused than edges. Macro lenses are designed for maximum flat-field sharpness.

- **Exposure changes.** Macro lenses may move the lens or optical elements away from the camera body and as it does this, it reduces the light to the sensor. The result is that your exposure will change, requiring a slower shutter speed or a wider aperture.

- **Limited focal lengths.** Macro lenses only come in a limited range of focal lengths, which can make certain types of macro photography challenging.

Using Different Focal Lengths

Focal length change is the name of the game if you want more than the usual close-up shot. Consider a variety of close-up gear to be able to use different focal lengths. Most photographers don't know that there are some amazing possibilities that come from shooting different focal lengths up close. Different focal lengths give results that offer important visual differences for macro photography.

On the other hand, you might wonder if this is just about extra gear that you don't need. If you have a macro lens, won't that get you the shots you need?

Maybe, but you will be missing some important, fun, and dynamic possibilities. Being able to use different focal lengths up close makes a big difference in the imagery you shoot. Here are some benefits of using a wide-angle focal length up close (Figure 5.7):

- **Showing environment.** A wide-angle up close gives you a whole new look at the surroundings and environment of your subject, showing how your subject lives or is situated in the world.

- **The ecology lens.** You might think of a wide-angle as the ecology lens because it shows off the connection of the subject to its environment.

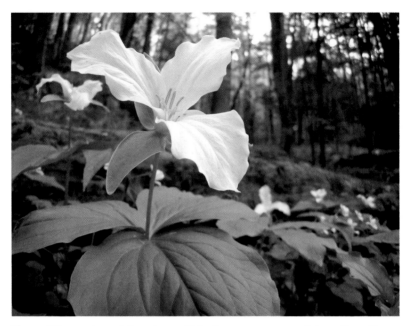

Figure 5.7 A wide-angle lens shows off the forest environment of this trillium flower.

- **Deep space and more depth.** Put on a wide-angle and the impression of space and depth around your subject changes—it looks deeper and backgrounds look farther away.
- **More depth-of-field.** Apparent depth-of-field is increased.

Here are some benefits of using a telephoto focal length up close:

- **Space between you and the subject.** The first thing you notice with a telephoto is that you can back off from your subject and still get close shots. That can be very important for photographing insects (Figure 5.8), for example, or dangerous critters, such as a rattlesnake.
- **Isolate the subject.** You might think of the telephoto as the isolation lens because of the way it can help isolate a subject against the background.
- **Flatter space and depth.** You flatten distances and depth with a telephoto. It makes things look closer together, but it also brings backgrounds visually closer for interesting effects.
- **Less depth-of-field.** With a telephoto, apparent depth-of-field decreases, letting you contrast the subject to an out-of-focus and often blended background.

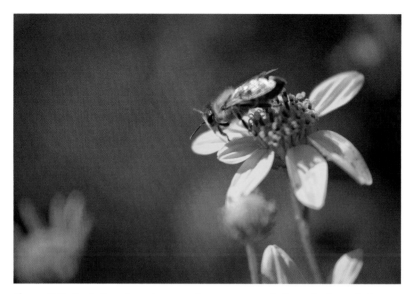

Figure 5.8 A telephoto lens gives space between you and a bee, plus it can isolate the subject against a simple background.

Put extension tubes or an achromatic close-up lens on a zoom lens and you can quickly see the possibilities of varying your close-ups. You will discover that the wider (maybe even wide-angle) and most telephoto parts of the zoom give you totally different results. They even act differently when focusing!

For wide-angle close-ups, there are few true macro lenses. The best option for wide-angles is the achromatic close-up lens, especially since extension tubes generally do not work that well with wide-angle lenses. In addition, when you use an achromatic close-up lens, you do not affect exposure (both macro lenses when used up close and extension tubes reduce the light to the sensor to at least some degree).

For telephoto focal lengths, macro options are pretty limited. You won't find a true macro over 200mm. Yet, you need a way to make telephotos focus close. Most don't. Either extension tubes or achromatic close-up lenses will work.

Changing Backgrounds

Backgrounds are very important to close-up photography. The right background can make or break the image and has a huge effect on how the subject appears in the photograph. Changing your focal length can change how the

background appears behind your subject quite dramatically when you are shooting up close. Sometimes it is worth using a different focal length simply because you can get a different background. These effects occur even when you change your zoom from wide to telephoto or the other direction. Here are some ways that you can use focal length to control your background:

- **Detailed backgrounds come from wider focal lengths.** Sometimes you need detail in the background for your picture (Figure 5.9). You may want to show a line of flowers going back into the distance. You may want to clearly show an environment around your subject.

- **Soft backgrounds come from telephoto focal lengths.** A telephoto focal length, especially when combined with a wide f/stop, will create beautiful soft backgrounds (Figure 5.10).

- **Special highlights come from telephotos.** Bright highlights in the background can take on sparkly shapes. They are taking on the shape of the inside of your lens. The more out of focus these highlights are, the stronger the shapes will be and a telephoto lens helps do exactly that.

Figure 5.9 Wider focal lengths offer more detailed backgrounds.

■ **Defined colors.** With a wide-angle lens up close, background colors, even those that are out of focus, will be defined and distinctive in the image.

■ **Blended colors.** With a telephoto lens up close, background colors will be out of focus and blended in gentle tonalities.

Figure 5.10 Telephoto focal lengths offer blended, soft backgrounds.

Chapter 6

Shooting Tips for Specific Subjects

Landscapes or sports can't be photographed at just any time because you have to be at special locations to capture those subjects, and even the time you are there can be critical. You can't take travel photographs unless you are traveling. And you can't capture images of people unless you are around people. Plus, humans can be challenging subjects who can talk back to you!

Close-up photography can be done at any time and in any place. There are always subjects for close-ups. In fact, so many things look different when you get in close that even the most common of subjects can be totally dramatic. Close-up and macro photography offer you a wealth of subject matter that will have something available to you at all times. This is photography you can explore whenever the mood strikes you, and you will often learn something new about photography as you do.

Flowers

Flowers are one of the most popular subjects for macro photography. Nearly every photographer will shoot them at one time or another. They offer colorful, detailed subjects that do not run away from you, yet always present something beautiful to photograph. They are always available. You can purchase flowers at low cost all year round, even from the grocery store! And in the growing season, flowers are nearly always a handy subject as well.

A challenge with flower photography is that the subject matter can be almost too beautiful. Flowers will present such stunning colors and designs that it seems like all you have to do is get up close and squeeze the shutter and you'll have a great picture. Unfortunately, that doesn't always work out. A flower and a photograph of a flower are two different things.

Here are some ideas on how to approach your flower close-ups to get better photographs:

- **Get down to the flower's level.** Most flower photos are taken from slightly above the flower level looking down at about a 45-degree angle. Since most photographers shoot in this way, flower pictures start to look the same. Also the background, the ground itself, is often too close to the flower, which doesn't allow you to separate it as well in the image. Try getting down to the flower level—its "eye-level" for the shot (Figure 6.1).

- **Wind can be a problem.** Flowers are often on a very flexible stalk that moves quite easily in the wind. Sometimes you can block the wind with a reflector but sometimes not. If you are patient, you'll often find a pattern to the movement of the flower so that you can time your shot to when it is still. You can also set your camera to continuous shooting and simply hold the shutter down as the flower moves. You will usually get at least a few sharp images with a flower in a good place in the frame.

- **Work the single flower.** Look for the right flower that looks good because of the background behind it as well as the light on it, then go in close to just that flower. Don't be afraid to put that flower off center in the image and use some interesting space to one side or another.

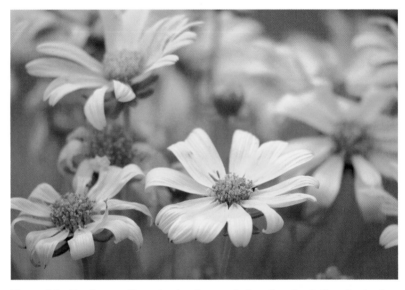

Figure 6.1 Get down to flower level and try a telephoto lens for shallow depth-of-field.

■ **Work the small group of flowers.** Find an interesting group of two or three flowers. Find an angle that creates a relationship among these flowers. It can be very interesting to have the group all in a line across the image or have them go from foreground to background.

■ **Emphasize a mass of flowers.** Use a telephoto lens to compress the distance between the flowers and get down low so that a large group of flowers all come together in the image. Get in close enough so that this mass of flowers fills the entire frame from edge to edge.

■ **Watch that background.** It is really easy to focus so strongly on the beautiful flower in front of you that you don't see what is happening to the background. Be sure to check your LCD playback to ensure that the background is complementing and not distracting from your subject.

■ **Use sidelight for form and texture.** Flowers often have wonderful three-dimensional form and texture. This can be emphasized and brought out by a low sidelight going across the top of the flower.

■ **Make flowers glow with backlight.** When the light comes from behind the flowers, it will make translucent petals glow with color.

■ **Play with shallow depth-of-field.** Try photographing flowers with a telephoto set to its widest f/stop. This is something a lot of photographers are afraid to do, yet it can give beautiful, soft, and romantic-looking images. Just choose your point of focus carefully.

■ **Go in tight for the abstract.** Get in really close to bigger flowers so that you lose the edges of that flower. Then start looking for abstract shapes, colors, and forms rather than trying to simply photograph the flower.

Plant Details

When you can't find flowers, you can always find plant details that make fascinating macro studies. Plant details work for subjects throughout the year, in all seasons. In fact, these details can offer you some wonderful opportunities for photography even in winter.

Plant details are a great for exploring photography beyond the subject. Dead leaves, for example, aren't necessarily interesting for the subject matter, but they will offer color, shapes, and textures to work with photographically. Indeed, color, shape, and texture are three key photographic elements that will help you find plant details that will make good photographs. Here's how:

■ **Look for color.** Color can be such an interesting part of a close-up image. Look for bold colors that really stand out against their surroundings.

- **Find shapes.** Focus in on the interesting shapes in plant leaves, stem structure, fruit, and even the intersection of all of these.

- **Emphasize texture.** In the right light, textures of plant details make fascinating photographic studies. Remember to look for strong sidelight to bring out texture.

- **Look for patterns.** Patterns are another good way of defining a photograph when coming in close to plants. Move in until the pattern fills your image area.

- **Photograph early and late in the day.** Midday light can be harsh on plant details.

- **Use hard light.** Hard light is light that has a very strong contrast between highlights and shadows. This can be a very dramatic light that can spot light your subject, bring out texture, or make translucent plant parts glow.

- **Use soft light.** Soft light has a gentle change in tonality from the bright areas to the dark areas. This can be an attractive light for showing off patterns, soft colors, and gentle forms (Figure 6.2).

- **Work with abstracts.** Abstract arrangements of plant details can be a terrific part of close-up photography. These details take on whole new relationships and designs when you get so close that you abstract them from their surroundings.

Nature Patterns

Many photographers have discovered the patterns of nature at a distance. Interesting patterns are found in sand dunes, waves, rocky beaches, forests, and so forth. Equally interesting patterns can be discovered as you get in close with your camera and lens. Some of these patterns will be plant details as just described. But there are a lot more possibilities for nature patterns beyond plants, from rock details to water to patterns on an animal.

Many patterns look best with a soft light. Hard light with lots of shadows can overemphasize texture and form that may obscure the actual patterns of an object. Sometimes texture itself can be a pattern and that will need a harder light. But a lot of nature's patterns are based on how colors and tones interact and display on the object that you are close to. Here are some other things to think about when capturing close-up nature patterns.

- **Look for surprising patterns.** People don't usually look at the world in close-up or at macro distances. As you explore the world around you with your close-up gear, you will discover surprising patterns that you might never have seen otherwise. These can make great photographs.

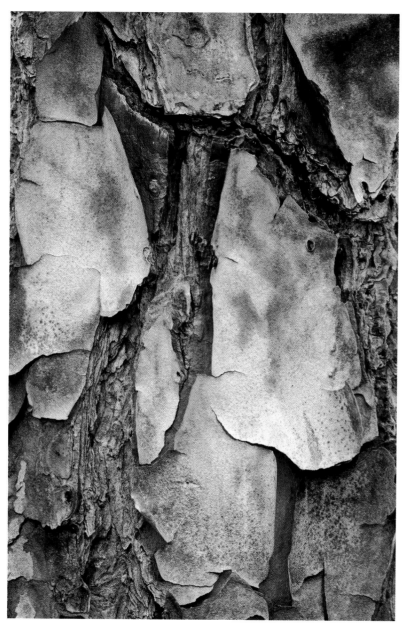

Figure 6.2 Soft light shows off the colors and patterns of this tree bark detail.

- **Use a telephoto.** Many patterns look best when the close-up perspective is flattened somewhat by the use of a telephoto lens or focal length. A telephoto will be a necessity when you are photographing certain subjects (such as feathers on a bird) for their patterns.

- **Work with front light.** Front light fills in the shadows of an object and helps emphasize the tonal and color variations that make up a pattern. A telephoto focal length can keep you back from the subject to help you avoid putting your shadow on the subject.

- **Use a flash on the camera.** While many close-up subjects look best with an off-camera flash, an on-camera flash or even a ring flash can more evenly illuminate your subject so that the patterns show up better.

- **Work the abstract design.** A lot of macro patterns really look their best when they are abstracted from the actual subject. The pattern becomes a design that fills up your image area.

- **Look for small contrasts.** Break up the design of a pattern by finding something that contrasts with the overall pattern within your image area (Figure 6.3). This could be something that has a different shape, unique color, or is different in some other way.

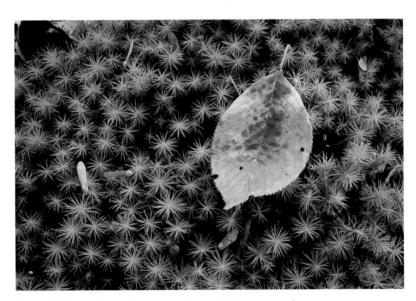

Figure 6.3 A brown leaf creates contrast with the pattern of moss.

Mushrooms and Fungi

Mushrooms are somewhat of a seasonal subject matter for close-ups, but they almost always attract photographers' attention. Mushrooms include unique shapes and forms that sometimes surprisingly pop out of the ground or off of trees and stumps.

Spring and late fall are key months for mushroom photography. The moisture of spring along with the warming temperatures will encourage mushrooms to sprout from the ground. Late fall's bare trees make the bracket fungi of trees more easily seen. Both times offer unique opportunities for close-up and macro photography. Here are some things to think about:

- **Get out after a rain.** Mushrooms can literally sprout overnight if you get rain after a period of drier conditions.
- **Search out the unique.** Mushroom and fungi details are often quite unique but you don't see them until you get really close. Discovery of cool details is probably one reason for the popularity of such photography.
- **Get down to "eye level" with mushrooms.** Mushrooms often grow very low to the ground. A lot of photography is done with the camera pointed at a 45-degree angle to the mushroom. Put your camera on the ground to get a totally different perspective on this subject (Figure 6.4).

Figure 6.4 Get down to the level of a mushroom to see what it really looks like.

- **Shoot straight down for shapes.** Mushrooms can have these beautiful round shapes that are best seen when shooting straight down on them.

- **Brighten them with flash.** Often mushrooms and fungi live in very dark conditions. This can make it difficult to get good light on them, so a flash can be very helpful. An off-camera flash will give the best form and texture for these subjects.

- **Take along a mirror or other reflector.** A small mirror can be an excellent reflector for work with mushrooms. Since they frequently grow in dark areas, a mirror can help direct light more effectively on them.

Lichens and Mosses

Lichens and mosses are tiny plants or plantlike organisms that grow close to the ground or tight to objects and often don't look like much until you get up close. When you get close to them, they can offer surprising colors, patterns, and textures. Lichens (which are a unique combination of a fungus and an alga) come in all sorts of wild formations and arrangements that can only be seen when you are up close. You will find abstract color designs that can rival that of painters such as Paul Klee. Mosses offer shades and tones of green that you might never know exist until you get in close to them.

You really have to get down and close to these subjects to appreciate their potential for subject matter or close-up photography (Figure 6.5). It can be fascinating to attach a macro lens, set it to a very close distance, then go in closer and explore rather than only photographing what you first see from a distance. Here are some other ideas for photographing lichens and mosses:

- **Shoot from above for patterns.** Lichens, especially, have great patterns when you look at them from directly above.

- **Shoot from low down for cool effects.** Both lichens and mosses create some very interesting looks when your camera is down at their level. People rarely see these organisms at that level, so immediately you get a unique photograph. A camera with Live View can really make this a lot easier to do because you're better able to see what the lens is seeing.

- **Use shallow depth-of-field for emphasis.** Since lichens and mosses are so small, you have to really get in close in order to photograph them. Depth-of-field is narrow anyway, so use it for emphasis. Highlight and show off parts of the subject by limiting sharpness to a very small plane.

- **Try backlight for moss.** Most has very thin leaves so even a slight backlight will give them a feeling of translucence. Backlight can make the leaves glow with color, though too strong a backlight can be unattractive.

Figure 6.5 Moss and lichens reveal colors, texture, and patterns up close that are easy to miss from a distance.

- **Use sidelight for crusticose lichens.** Crusticose lichens are the lichens that look like a crust on a rock. Sidelight will really make their wonderful textures and forms show up.

- **Look for unique lighting effects.** When you are down low and up close to moss, you will often find that moving just a slight distance will tremendously change how the light looks from foreground to background.

- **Back to abstract designs.** You can't miss with lichens on rocks for interesting abstract designs. Get in really close so that the shapes and colors create interesting patterns for your composition.

Insects

Insects are the most common type of animal on earth. While they can be annoying and unattractive, some insects are stunningly beautiful, especially when you get up close to them. Insects can make outstanding macro subjects because they bring you into a realm of a world that is unseen by most people. Just photographing them in all their detail will result in unique images.

A big challenge for insect photography is that they are alive and move. Just when you think you have them in focus, they fly away. That's just a fact of life when photographing bugs! However, with some practice, you can get some interesting and sensational photographs. Here are some ideas to do just that:

- **Look for insects around flowers.** Flowers attract all sorts of insects, from butterflies to bees. When they are busy feeding on pollen and nectar in flowers, they will often pay less attention to you.

- **Use a telephoto lens.** A telephoto focal length for insect close-ups helps for two reasons. First, it keeps you at a distance from the insects so they are more likely to let you get close. Second, it will keep you away from insects that might sting or bite.

- **Shoot early in the day.** Insects tend to get busier and more active as the day warms up. By looking for them earlier in the day, they will be cooler and a little slower when moving around.

- **Watch your approach.** Insects are small creatures that have a lot of predators that eat them. They get very sensitive to a big lens coming in close to them or your arm bumping against the plant they are on. These things will often make them leave.

- **Avoid sky behind you.** Some insects have very good eyesight and can see you coming from a distance away. However, almost all insects are really sensitive to changes in brightness and will react negatively if they see your silhouette against the sky.

- **Use a high ISO and hand-hold your camera.** Often you will have to follow an insect around, so using a tripod will be impractical. With a high ISO, you can shoot with a faster shutter speed to ensure sharper pictures when hand-holding.

- **Use manual focus.** Autofocus will generally drive you crazy when you are trying to photograph insects. Use your camera's manual focus, preset the focus to a point where you think will be appropriate, then move the camera to and from the insect for focus.

- **Focus on the eyes.** All animals look best when their eyes are sharp. Because depth-of-field is so narrow when you're up close, be careful that your focus point is at least on the eyes of your insect (Figure 6.6).

- **Try a flash.** Flash can be very helpful with insects because it is of such a short duration. That can stop the movement of an insect even to the point of stopping its wings. This also can eliminate camera movement during exposure that might cause unsharpness.

Figure 6.6 Be sure the eyes are sharp for insect photography.

Spiders and Spider Webs

Spiders are unique small creatures that can be both disturbing yet fascinating to photograph. Spider webs are a great subject for macro photography—they offer much variety and a lot of interesting possibilities. Spiders themselves come in all sorts of colors and shapes which can offer unique macro subjects.

Spider photography is not all that different from insect photography. Many of the ideas used for photographing insects can be used for photographing spiders. A big difference for spiders is that a lot of photography of these creatures will be done when they are on their web or even just the web itself. Here are some ideas for getting great close-ups of spiders and their webs:

- **Look for webs.** Webs are the most obvious sign of spiders. Webs come in all sorts of shapes, sizes, and arrangements.
- **Use backlight for webs.** Webs show up nicely if you can get them backlit against a dark background (Figure 6.7).

Figure 6.7 Backlight makes the web and spider show up well against the dark background in this photo.

- **Shoot early in the day.** Spider webs often have attractive drops of dew on them early in the morning. They can make webs literally look like jewelry. In addition, spiders will be cooler and a little slower moving around.

- **Look for certain spiders around flowers.** Since flowers attract all sorts of insects and spiders are predators, a number of spiders will hang out near flowers in order to catch their prey. Some of these spiders are beautifully camouflaged and match the color of the flowers.

- **Watch your approach.** Spiders are also small creatures that have a lot of predators that will eat them. Spiders that don't build webs usually have very good eyesight and will see you coming. All spiders will be sensitive to your bumping against the plant they are on. These things will often make them hide.

- **Use a tripod for web photography.** Since webs don't move to new spots, you don't have to follow them. You can easily set up a tripod for maximum sharpness and the ability to use a low ISO setting.

■ **Wind can be a problem.** Webs move all too readily in the wind. Sometimes you can block the wind with a reflector but sometimes not. If you are patient, you'll often find that there will be a pattern to the movement of the web so that you can time your shot to when it is still.

■ **Use a high ISO and hand-hold your camera.** Often you will have to follow a spider around, so using a tripod will be impractical. With a high ISO, you can shoot with a faster shutter speed to ensure sharper pictures when hand-holding.

Shells and Fossils

Shells of clams and snails as well as fossils (which include many shells) offer excellent subject matter for close-up photography. These subjects have interesting textures, shapes, and forms that can be isolated and dramatized in a composition. They also can really offer some fascinating and unusual details when you get down to a true macro level of photography. You can show off things that the average person never sees.

You can find shells almost anywhere there is natural water. Sea shells are obviously by the ocean but other types of shells are common around inland water as well. Sometimes you need to clean the shells up in order to get a good photograph of them. That might mean simply rinsing them off in nearby water or you may have to take them somewhere for a more thorough cleaning. Fossils are found in sedimentary rocks in locations throughout the country. When you find one fossil, you'll often find many. Here are some things to think about when photographing shells and fossils:

■ **Use a tripod.** These subjects don't move so you gain a lot of control over how you shoot them. By using a tripod, you can ensure that your images are sharp.

■ **Light for form and texture.** Shells and fossil are all about form and texture (Figure 6.8). Some of the most interesting things about them involve their three-dimensional qualities as well as texture. Use sidelight or backlight that emphasizes these features.

■ **Choose small apertures.** These subjects often look their best with as much of the shell or fossil in focus as possible. Using a small aperture results in more sharpness.

■ **Shoot with shorter focal lengths.** Shorter focal lengths will also result in more depth-of-field and show off your shell's or fossil's details.

Figure 6.8 A gentle sidelight brings out the form and texture of this shell fossil impression.

- **Keep your camera parallel to the subject.** Your camera's plane of focus is parallel to its back. By keeping your camera parallel to your shell or fossil subject, you also keep the plane of sharpness aligned with your subject, resulting in sharper images.

- **Isolate your subject.** Shells, especially, are often found with lots of other shells. That can make your image rather distracting. An effective way of isolating these subjects is to put them on a piece of white plastic or cardboard. Be sure to expose so that the white is white and not gray.

- **Try wetting the subject.** Both shells and fossils will often change in appearance when they are wet. Sometimes wetting them will help details show up better.

Rocks and Minerals

Rock and mineral photography is similar to photographing shells and fossils. They also have fascinating forms, shapes, and textures that look good in a close-up. In addition, rocks and minerals include some three-dimensional forms that you won't see anywhere else, plus patterns that will remind you of

alien worlds when you get to macro distances. Minerals also include translucent crystals that add internal depth to their forms.

Rocks and minerals are nearly everywhere. There is no question that most locations will favor certain rocks or minerals, but there is always something that can provide close-up subjects. One of the cool things about rocks is that they can vary dramatically as you move from location to location. In addition, many places that feature unusual rocks will have rock stores that will allow you to purchase special rocks and minerals that can make great subject matter for your camera. This also means that you don't have to worry about collecting rocks where there are laws against that. Try these ideas for getting better images of rocks and minerals:

- **Use a tripod.** Rocks and minerals don't move! Use a tripod to ensure that sharpness is kept as high as possible.

- **Keep your camera parallel to the subject.** This is just as important for rocks and minerals as it is for shells and fossils. Since a camera's plane of focus is parallel to its back, keeping the camera parallel to the key surfaces of your subject will result in sharper images.

- **Light for form and texture.** Rocks and minerals often have amazing three-dimensional qualities as well as strong textures. A sidelight or backlight emphasizes these features.

- **Light for translucence.** Whenever you have a rock or mineral that is translucent, get a light behind it. Sometimes you can even put your rock or mineral on a white piece of Plexiglas and then put a light behind that.

- **Choose small apertures.** By using a small aperture, you gain as much sharpness in depth as you can in order to cover the thickness of your rock or mineral subject.

- **Experiment with large apertures for rocks on location.** You might not consider a large aperture, which gives limited depth-of-field, for rocks or minerals. But when you are shooting them in the field, you may need to isolate them from a busy background, and limited depth-of-field can help.

- **Try wetting rocks.** Rocks usually change in appearance when they are wet. Colors and patterns often show up much better.

- **Look for abstracts.** When you get in close to a rock, you will often find fascinating patterns (Figure 6.9). Get in tight so you don't see the edges of a rock, just these patterns.

- **Break the rock.** Many rocks have some of their best patterns inside and need to be broken for you to see and photograph them. Protect your eyes and other parts of your body, as well as your camera and lens when you are breaking the rock.

Figure 6.9 The abstract patterns of this rock are revealed by a tight composition and the light.

Jewelry

Jewelry is a very unique subject with special needs that can make it hard to photograph. The biggest challenge of photographing jewelry is that most of it is very shiny and reflects everything around it, including you and your camera. Jewelry reflects dark things as well as light things, creating patterns that can distract from the jewelry.

In addition, jewelry can reflect bright lights in annoying ways. The shine of much jewelry will reflect the sun or a flash right back into the camera and put hotspots in places where you don't want them. Sometimes you will be photographing jewelry that does not have a lot of shine to it. In those cases, you can use hard light and some of the techniques that were described for photographing rocks and minerals. But most jewelry has at least some shiny elements to it and you have to be careful of that. Here are some ways to work with jewelry up close:

- **Use reflectors.** If you place white reflectors all around the object, the shiny surfaces of the jewelry will reflect the white reflectors which will give shiny surfaces dimension and form. Cut up pieces of foam board and place them around your subject.

■ **Use soft light.** The light on your jewelry needs to be soft and diffused or reflected off of white reflectors. Use diffusers or reflectors that are considerably larger than your subject for modifying your light. Light coming directly from a light source, whether that is the sun or flash, will produce too harsh a light for the shiny surfaces of the jewelry.

■ **Put a reflector around your lens.** One way of preventing reflections of you and your camera in the jewelry is to take a piece of white foam board, cut a hole in it for your lens, then place it over your camera and lens. Now the jewelry will reflect this foam board and not you.

■ **Tent your subject.** Photographers who regularly photograph jewelry will build a white tent-like structure from white diffusion material (which could simply be a white shower curtain) to totally surround the subject. A hole is cut for the lens of your camera. The light is directed to the outside of the tent which fills the space with a luminous light and lots of white surfaces for the jewelry to reflect. Photographic light tents are also available for purchase.

■ **Use mirrors.** Sometimes it can be difficult to get light into a small area of the jewelry that really needs to be bright. Use a small mirror, such as one you would get from the drugstore for a makeup kit, and direct light into areas that need it.

■ **Use a tripod.** Jewelry is like the subjects discussed that don't move. You will get maximum sharpness and be able to use small apertures for maximum depth-of-field when you use a tripod.

■ **Simple backgrounds and surfaces.** Backgrounds, including the surfaces your jewelry sits on, can really help set your jewelry off in a photograph. Dark, non-reflective surfaces, such as black velvet, can create a very elegant look for jewelry (though realize that any part of the jewelry facing this surface will be dark as well). A simple white surface can also look attractive (Figure 6.10), but you need to be sure you do not underexpose this. A sheet of white or black Plexiglas can also make for an interesting jewelry background because the jewelry will be reflected in it.

■ **Complex backgrounds and surfaces.** Many photographers are tempted to position their jewelry among other objects, including other jewelry. You have to be very careful of this because remember that your jewelry will often reflect everything, including surrounding objects. That can make the subject less distinctive and you can lose some of its shape and form.

Figure 6.10 A simple white background and reflectors all around the object help this ring show off its aged beauty.

Toys and Similar Objects

Toys can make fine subjects for close-ups. Photographers can show off unusual features of the toy or create complex scenes of toys together that tell or illustrate a story.

Toys vary a lot as to how distinctive their shapes are, how translucent they are, what sort of texture they have, and so forth. Many of the things that are discussed above about photographing dimensional objects such as shells or rocks will apply to close-ups of toys. However, most toys are also very colorful with unique patterns. Often capturing that color and pattern is key to a good close-up image of a specific toy. Here are some things to think about when photographing toys and similar objects:

- **Use gentle light for colors.** Use a diffuser or a reflector for your light so light does not hit the toys directly from the source. This will soften the edges of the shadows and help color differences show up better.

- **Try strong light for drama.** Sometimes a toy looks good in dramatic light. Be sure that the light is hitting the toys directly without being diffused or bounced off of a reflector. Sidelight often works well for this, especially if it is not totally to the side but is in between a front and sidelight. Use and work with the shadows.

- **Use front light for colors and patterns.** A front light that is close to the camera will fill in shadows and emphasize patterns and colors on the toys. The challenge with this light is that you will lose form and texture. Sometimes you can compromise on this light by moving it a little bit to the side to create some shadows.

- **Keep your light directional for form.** Three-dimensional forms of toys need some direction to the light to create shadows (Figure 6.11). You can get direction with both strong and gentle lights if you put that light somewhat to the side or even behind the subject.

- **Tent toys.** Putting up a tent of translucent material around the toys will create a soft and even light over all of them. That will really help with reflective toys, but it will also work to show off subtle colors and tones in the toys.

Figure 6.11 A gentle sidelight brings out the form in the toy cat in this composition.

- **Light translucent toys from behind.** The translucence of a translucent toy is only going to show up if you have light behind it. Sometimes it can be effective to place that light directly behind your subject.

- **Use reflectors.** Reflectors can be very useful to direct light into dark parts of the toys and their surroundings. This can be especially important if your light is behind your subject, but any strong directional light will often need reflectors opposite of the light.

eBay

eBay has become an extremely popular place to sell things. Photographs of the objects being offered for sale are an important part of the process. In fact, eBay notes that the right photograph can help an object sell for a higher price and the wrong photograph can make it hard to sell. They consider photos so important that they even have an eBay photo center with a downloadable guide for better photos for eBay sellers.

The key to close-ups for eBay is that the subject must be the star of the image. This is not the place for creative photography. The subject must be shown clearly, sharply, and well-defined for the buyer. Here are some tips for creating better close-up images for eBay:

- **Keep it simple.** This is not the place for showing off photographic skills. The image needs to be simple and direct for the buyer to clearly understand what the product is. Avoid shooting your subject against a busy background.

- **Try a white background.** A white background simplifies the photograph and clearly shows off the subject. Make sure your camera does not underexpose a picture with a white background, however.

- **Expose for the subject.** It is very important that your exposure makes the subject look good and shows off all of its important details.

- **Get in tight to the subject.** No buyer cares about seeing a lot of background of any kind with the object for sale. Compose your image tightly to show off the subject.

- **Avoid wide-angle lenses.** Wide-angle lenses can distort your subject in ways that can make the object for sale less appealing.

- **Shoot at angles that show off the subject.** Move around your object and try different angles until you find the best angles that really show off what is truly important about your subject.

Figure 6.12 A white background emphasizes the subject but must be exposed to keep it white.

■ **Take multiple pictures.** eBay encourages sellers to upload multiple pictures showing off the object for sale from different angles. This has been proven to help sales.

■ **Use soft, gentle lighting.** Avoid harsh lighting because that will not show off all of the important details. Diffuse the light or bounce it off of a reflector to create a gentle light with soft-edged shadows.

■ **Use reflectors.** Reflectors can be very important to throw light into shadowed parts of your objects to reveal key details.

■ **Use a tent.** Many objects look good for eBay purposes when they are photographed in a tent of white diffusion material. A light directed to the outside of the tent is diffused from the start and all of the white surfaces create reflectors all around the subject to fill in shadows.

■ **Use a tripod and a small f/stop.** Objects for sale on eBay don't move, so use a tripod to ensure maximum sharpness and to enable the use of small apertures for maximum depth-of-field.

Food

Food is a unique and challenging subject for close-up photography. Food photography has gotten more popular as food television shows have become popular. Yet, a lot of food photography does not make the food look very appetizing. Go to many small, independent restaurants and check out the pictures of the food—the images are obviously shot with the flash on the camera without much thought to how the light might actually make the food look appealing.

Professional food photographers will spend a lot of time setting up a studio for optimum food photography. You don't have to go to that extreme. Keep it simple, but be aware that how you use light is the most critical part of good food photography. Here is a short list of things that you can do to make your food look more appetizing when shot in close-up:

- **Use a high and well-diffused backlight.** You don't have to do anything else for light in order to get attractive food pictures. A lot of professional food photography is shot in exactly this way. Either use a big diffuser for your light (and be sure your light fills the diffuser) or bounce it off of a big white card that is positioned above and slightly behind the food in relationship to the camera position (Figure 6.13).

Figure 6.13 Keep it simple when photographing food. A diffused light source above and slightly behind these cookies gives them form without making them look harsh.

- **Choose small apertures.** Food generally looks its best when sharp throughout the depth of the food itself. Use a small f/stop for maximum depth-of-field.
- **Use a tripod.** It is critical that food looks sharp for viewers to find it appealing.
- **Use reflectors.** Even though your light is diffused and gentle, because it is a slight backlight, there will be shadows. Use reflectors to fill in those shadows as needed.

Artwork

Many times photographers are asked to photograph artwork such as paintings, ceramic sculptures, and other small objects that need close-up techniques. Rarely will you be photographing artwork to be creative. You are trying to capture the creativity of the artist in the photograph and let the artwork speak for itself.

Objects that have dimension, such as small sculptures, can be photographed in the same ways that you would photograph toys or rocks and minerals. All of the hints and tips provided in those sections in this chapter will help you with that type of artwork. In addition, you may find some of the ideas in the eBay section helpful as well. You have to decide how important shadows are to portraying dimensional artwork—sometimes they are but sometimes they are distractions. It all depends on the artwork itself.

Flat art, such as paintings and drawings, have some different photographic needs. Here are some ideas for doing just that:

- **Place any lights to the side.** Put your lights at about a 45-degree angle to the artwork and to one side. A good way of doing this is to use two lights opposite each other on the sides of the art (Figure 6.14). However, if you want to show off texture, such as the paper, canvas, or brush strokes, use one light, keep it to the side and well away from the art or you will get uneven lighting.
- **Watch for glare from the light.** One reason for using lights at about a 45-degree angle is that you're less likely to get glare off of the artwork. Some types of artwork have shiny surfaces, such as oil paintings, which may require some very careful positioning of the light.
- **Set your white balance for the lights.** The color of artwork is critical so you cannot afford to use auto white balance, which can be very inconsistent. Set a specific white balance based on the type of light you are using to illuminate your subject.

Figure 6.14 If your artwork has texture in it that you want to show, use a single light to one side of your art, but avoid putting it right next to the art.

- **Keep the artwork flat.** If you can, use a piece of glass to cover the artwork and keep it flat.
- **Carefully focus on the art.** Be sure your camera is focused exactly on the surface of the artwork. You may need to use manual focus for this. If you have Live View, magnify that view and check your focus that way.
- **Keep your camera parallel to the art.** Your camera must be parallel to the artwork to produce sharpness across the entire work of art as well as for keeping the edges of the artwork parallel and aligned.
- **Use a tripod.** This is for all of the reasons described in the other sections above as well as to be sure that your camera is kept at the optimum position for focus and alignment.

Index

A

A (Aperture priority) mode
with macro lenses, 3
with standard lenses, 2–3
abstract designs, 47–48
in flower photography, 89
in lichens and mosses
photography, 95
for nature patterns, 92
for plant details, 90
in rock and mineral photography,
101–102
accessory flash
for mushroom and fungi
photography, 94
for nature patterns, 92
**achromatic close-up lenses, 78–80,
83**
adapter rings, 75
for achromatic close-up lenses, 79
Adobe Lightroom for soft light, 61
**Adobe Photoshop/Photoshop
Elements for soft light, 61**
AF (autofocus)
locking or limiting focus, 20
sharpness and, 19–20

angles
for eBay photography, 106
for environmental close-ups, 40
for flower photography, 88
for lichens and mosses
photography, 94
for mushroom and fungi
photography, 93
planning for, 32–33
for sharpness, 22–23
for solid light, 60
aperture
DOF (depth-of-field) and, 14–15
for food photography, 109
with macro lenses, 81
for rock and mineral photography,
101
selecting, 16–18
sharpness and, 4
for shell and fossil photography, 99
Aperture priority mode (A). *See* A
(Aperture priority) mode
APS-C and noise, 8
**arrangement in composition,
29–30**
artwork photography, 109–110
Auto WB (white balance), 11
autofocus (AF). *See* AF (autofocus)

B

backgrounds, 34–36
 accessory flash and, 70
 colors in, 36
 contrast in, 35
 diffusers and, 64
 for eBay photography, 106–107
 environmental close-ups and,
 40–41
 flash, controlling brightness with,
 65
 for flower photography, 89
 focal lengths and, 83–85
 for jewelry photography, 103–104
 light in, 35
 sharpness of, 36
 spot light and, 53
 visual relationships in, 38
backlight, 53–55
 dimensional light and, 56
 for flower photography, 89
 for food photography, 108
 for lichens and mosses
 photography, 94
 for shell and fossil photography,
 99–100
 soft light and, 61
 for spider/spider web photography,
 97–98
 textural light and, 58
balance in composition, 44–45
beanbags, 26–27
blank skies, avoiding, 61
blurring
 backlight and, 54
 bokeh, 36

bokeh, 36
brightness
 dramatic light and, 51–52
 flash for controlling, 65
built-in flash
 for nature patterns, 92
 working with, 67–68

C

camera handling for close-ups,
 9–10
camera shake. See also image
 stabilization
 close-ups magnifying, 14
car sunshades as reflectors, 62
centered subjects, problems with,
 41–45
close-up lens attachments, 73–75
cloudy days
 flash on, 65–66
 WB (white balance) for, 11
colors
 in backgrounds, 36
 in foregrounds, 37
 isolating subjects and, 39
 in plant details, 89
 soft light and, 60–61
 wide-angle lenses and, 85
communication in composition,
 29–30
composition, 29–48
 abstract designs in, 47–48
 of backgrounds, 34–36
 balance in, 44–45
 centered subjects, problems with,
 41–45
 details, focus on, 45–47

of foregrounds, 36–38
isolating subjects, 38–39
rule of thirds, 42–43
space in, 45
tight close-ups, 47–48
unity in, 44–45
vertical/horizontal compositions, 45–46
whole subjects in, 45–47
continuous shooting with MF (manual focus), 21
contrast
in backgrounds, 35
dramatic light and, 51–52
in foregrounds, 37–38
isolating subjects and, 39
in nature patterns, 92
with soft light, 61
custom WB (white balance), 12
cutting boards as diffusers, 64

D

daylight/sunlight
shadows and, 55–56
textural light and, 58
WB (white balance), 11–12
definition in composition, 29–30
definitions, 1–2
depth-of-field (DOF). *See* **DOF (depth-of-field)**
details
focus on, 45–47
plant details, shooting tips for, 89–90

diffusers, 63–65
for built-in flash, 67
for eBay photography, 107
for food photography, 108
for toy photography, 104
dimensional light, 56–60
with accessory flash, 70
for toy photography, 105
distance
with achromatic close-up lenses, 80
DOF (depth-of-field) and, 14
distractions in composition, 44
DOF (depth-of-field)
aperture and, 16–18
backgrounds and, 34–35
f/stops and, 4, 14, 16–18
in flower photography, 89
focal length and, 14, 18
focus points and, 18–19
in lichens and mosses photography, 94
sensor size and, 8
shallow DOF and sharpness, 13–14
wide-angle lenses and, 82
dramatic light, 51–56
dull light
front light and, 60
soft light and, 61

E

eBay, photographing for, 106–107
environmental close-ups, 40–41
 focal length and, 81–82
exposure
 with achromatic close-up lenses,
 80
 with backlight, 55
 for eBay photography, 106
 extension tubes and, 77
 with macro lenses, 81
 noise and, 7–8
 spot light and, 53
 with tele-extenders, 78
extension tubes, 76–77
external flash. *See* accessory flash

F

f/stops
 for abstract designs, 48
 DOF (depth-of-field) and, 4, 14,
 16–18
 for eBay photography, 107
 for environmental close-ups, 40
 with macro lenses, 3
 selecting, 16–18
 sharpness and, 4, 7
 with standard lenses, 2–3
 with tele-extenders, 78
filter plus rating, 75
 for achromatic close-up lenses, 79
filters, 73–75
flash, 65–72. *See also* accessory
 flash; built-in flash
 in insect photography, 96
 for mushroom and fungi
 photography, 94
 for nature patterns, 92
 ring flash, 71–72, 92
 twin flash, 71–72

flat subjects in abstract designs, 48
flowers
 insect photography and, 96
 shooting tips for, 87–89
 for spider/spider web photography,
 98
foam board reflectors, 62–63
focal lengths, 73–85
 backgrounds and, 83–85
 detailed backgrounds and, 84
 different lengths, working with,
 81–83
 DOF (depth-of-field) and, 14, 18
 extension tubes and, 77
 with macro lenses, 81
 for shell and fossil photography, 99
 soft backgrounds and, 84–85
focus. *See also* AF (autofocus);
 blurring; MF (manual focus)
 for artwork photography, 110
 in insect photography, 96–97
 with Live View, 24
 with macro lenses, 81
 sharpness and, 14
 with standard lenses, 2
focus points and DOF (depth-of-
 field), 18–19
focusing rails, 28
folding photo diffusers, 65
folding reflectors, 62
food photography, 108–109
foregrounds, 36–38
 colors in, 37
 contrast in, 37–38
 environmental close-ups and,
 40–41
 light in, 37
 sharpness of, 37
 visual relationships in, 38

fossil photography, 99–100
front light
 for nature patterns, 92
 for solid light, 59
 for toy photography, 105
fungi, shooting tips for, 93–94

H

handling camera for close-ups,
 9–10
hard light
 for nature patterns, 90
 for plant details, 90
high ISO noise, 7–8
highlights
 backlight and blurring, 54
 with telephoto lenses, 84
horizontal compositions, 45

I

image stabilization
 with macro lenses, 4
 with standard lenses, 3
 value of, 28
insect photography, 95–97
ISO sensitivity
 high ISO noise, 7–8
 in insect photography, 96
 with macro lenses, 4
 sharpness and, 7–8
 for spider/spider web photography,
 99
 with standard lenses, 2
isolating subjects, 38–39
 in abstract designs, 48
 in shell and fossil photography,
 100
 with wide-angle lenses, 82

J

jewelry photography, 102–104

L

landscape photography,
 composition in, 29–48
layering images with foregrounds,
 36–37
LCD
 changing display, 31
 light, working with, 50
 magnifying display, 31–32
 rule of thirds, 42
 sharpness determinations and, 5
 tips for using, 31–32
lens shades/hoods
 backlight and, 53
 with built-in flash, 67
 with macro lenses, 4
 with standard lenses, 3
lenses. *See also* macro lenses;
 telephoto lenses; wide-angle
 lenses; zoom lenses
 achromatic close-up lenses, 78–80,
 83
 close-up lens attachments, 73–75
 for environmental close-ups,
 40–41
 extension tubes, 76
 filters, 73–75
 standard lenses, quick guide to,
 2–3
 tele-extenders, 77–78
lichen, shooting tips for, 94–95

light, 49–72. *See also* **diffusers;**
 flash; reflectors; specific
 types
 for artwork photography, 109–110
 in backgrounds, 35
 backlight, 53–55
 controlling light, 61–65
 dramatic light, 51–56
 for food photography, 108–109
 in foregrounds, 37
 isolating subjects and, 39
 photographing light, 51
 for plant details, 90
 for rock and mineral photography,
 101
 for shell and fossil photography,
 99–100
 solid light, 58–60
 spot light, 52–53
 for toy photography, 104–106
 viewing/seeing light, 50–51
lines in abstract designs, 48
Live View
 DOF (depth-of-field) previewer in,
 35
 rule of thirds grids in, 42
 sharpness with, 23–24

M

macro lenses, 80–81
 quick guide, 3–4
 for wide-angle close-ups, 83
magnifiers for LCD, 31–32
manual focus (MF). *See* **MF
 (manual focus)**
matte white reflectors, 62
MF (manual focus)
 in insect photography, 96
 sharpness and, 20–21

mineral photography, 100–102
mirrors
 for jewelry photography, 103
 with Live View, 24
 for mushroom and fungi
 photography, 94
 as reflectors, 62
monopods, 27–28
mosses, shooting tips for, 94–95
**mushrooms, shooting tips for,
 93–94**

N

**nature patterns, shooting tips for,
 90–92**
noise
 high ISO noise, 7–8
 sensor size and, 9

O

**off-camera flash, working with,
 69–70**
out-of-focus. *See* **blurring**

P

patterns
 in lichens and mosses
 photography, 94
 nature patterns, shooting tips for,
 90–92
 in plant details, 90
photo diffusion boxes, 65
**plant details, shooting tips for,
 89–90**
**plastic cutting boards as diffusers,
 64**
portraits, environmental, 40–41

R

reflectors
>controlling light with, 61–63
>for eBay photography, 107
>for food photography, 109
>for jewelry photography, 102–103
>for mushroom and fungi photography, 94
>soft light, creating, 60
>for toy photography, 104, 106

ring flash, 71–72
>for nature patterns, 92

rock and mineral photography, 100–102

rule of thirds, 42–43
>exceptions to, 43

S

sensors and noise, 9

separation light, 54

Shade WB (white balance), 11

shadows, 55–56
>dimensional light and, 56
>for nature patterns, 90–92
>with ring flash, 71
>soft light and, 61
>textural light and, 57–58
>with twin flash, 71
>viewing/looking for, 51
>vignetting with achromatic close-up lenses, 79

shallow DOF and sharpness, 13–14

shapes
>in abstract designs, 48
>in plant details, 90

sharpness. *See also* DOF (depth-of-field)
>AF (autofocus) and, 19–20
>angles for, 22–23
>of backgrounds, 36
>challenges of, 4–5
>controlling, 13–28
>with flash, 65–66
>of foregrounds, 37
>ISO sensitivity and, 7–8
>isolating subjects and, 39
>with Live View, 23–24
>with macro lenses, 81
>MF (manual focus) and, 20–21
>shutter speed and, 4–7
>tripods for, 25–26

shell photography, 99–100

shiny reflectors, 62

shooting tips
>for artwork photography, 109–110
>for eBay photography, 106–107
>for flower photography, 87–89
>for food photography, 108–109
>for insect photography, 95–97
>for jewelry photography, 102–104
>for lichens and mosses, 94–95
>for mushrooms and fungi, 93–94
>for nature patterns, 90–92
>for plant details, 89–90
>rock and mineral photography, 100–102
>for shells and fossils, 99–100
>for spider/spider web photography, 97–99
>for toy photography, 104–106

shower curtains as diffusers, 64–65

shutter speed
 with flash, 65
 with macro lenses, 4
 sharpness and, 4–7
 with standard lenses, 2
sidelight, 56–57
 for flower photography, 89
 for lichens and mosses
 photography, 95
 for shell and fossil photography,
 99–100
 textural light and, 57–58
 for toy photography, 105
skies
 blank skies, avoiding, 61
 in insect photography, 96
soft light, 60–61
 for eBay photography, 107
 for jewelry photography, 103
 for nature patterns, 90–91
 for plant details, 90
solid light, 58–60
space in composition, 45
spider/spider web photography,
 97–99
spot light, 52–53
standard lenses, quick guide to,
 2–3
subjects. See also isolating subjects
 in abstract designs, 48
 balance and, 45
 centered subjects, problems with,
 41–45
 composition and, 30–31
 spot light on, 52–53
 whole subjects in composition,
 45–47

sunburst effect with backlight,
 54–55
sunlight. See daylight/sunlight

T

tele-extenders, 77–78
telephoto lenses, 73–74
 for abstract designs, 48
 achromatic close-up lenses and, 83
 with built-in flash, 67
 extension tubes for, 76
 highlights with, 84
 for insect photography, 96
 isolating subjects with, 39
 for nature patterns, 92
 sharpness and, 6
 for solid light, 59
 tele-extenders and, 77–78
tenting
 for eBay photography, 107
 for jewelry photography, 103
 for toy photography, 105
textural light, 57–58
 with accessory flash, 70
textures
 in plant details, 90
 in rock and mineral photography,
 101
 in shell and fossil photography,
 99–100
tight close-ups, 47–48
tilting camera for sharpness, 22–23
toy photography, 104–106
translucent light, 54
 for rock and mineral photography,
 101
 for toy photography, 106

tripods

for artwork photography, 110

beanbags with, 27

for eBay photography, 107

features of, 25–26

for food photography, 109

for jewelry photography, 103

for rock and mineral photography, 101

for sharpness, 25–26

for shell and fossil photography, 99

for spider/spider web photography, 98

twin flash, 71–72

U

underexposure and noise, 7

unity in composition, 44–45

V

vertical compositions, 45–46

vibration reduction. *See* **image stabilization**

vignetting with achromatic close-up lenses, 79

W

WB (white balance)

for artwork photography, 109

Auto WB (white balance), 11

challenges of, 11–12

custom WB (white balance), 12

Live View displaying, 24

white balance (WB). *See* **WB (white balance)**

whole subjects in composition, 45–47

wide-angle lenses

for achromatic close-up lenses, 79

DOF (depth-of-field) and, 14–15

for eBay photography, 106

as ecology lens, 81–82

for environmental close-ups, 40–41

wind

and flower photography, 88

and spider/spider web photography, 99

wired/wireless accessory flash, 70

Z

zoom lenses, 75

achromatic close-up lenses and, 79, 83

extension tubes and, 77

tele-extenders and, 77